IMAGES
of America

AROUND ELMONT
AND ROSEDALE

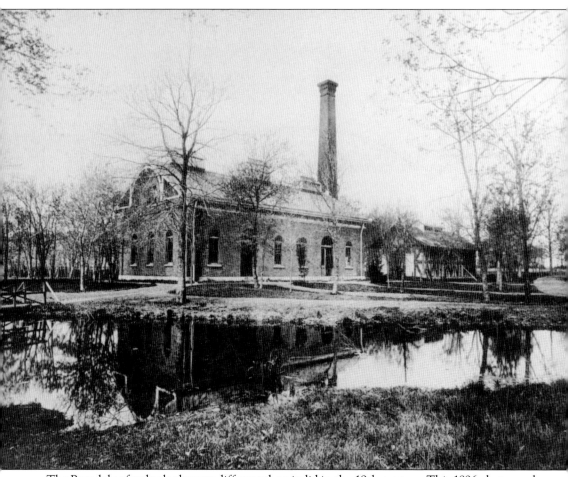

The Rosedale of today looks very different than it did in the 19th century. This 1896 photograph of a well station at a pond in Rosedale shows a major element of the Brooklyn Water Works system. Twin Ponds, Conselyea Pond, and Springfield Pond were all part of this system that fed water to the city of Brooklyn. (Queens Borough Public Library, Archives, Illustrations Collection–Rosedale.)

ON THE COVER: Among the landmarks in Elmont was Wal-Cliffe Skating Rink, located at the intersection of Belmont Boulevard and Johnson Avenue. Wal-Cliffe opened in 1931 and closed after a fire on January 16, 1988. This photograph is from 1939. (Nassau County Photograph Archive.)

IMAGES
of America

AROUND ELMONT AND ROSEDALE

Bill Florio

ARCADIA
PUBLISHING

Published by Arcadia Publishing
Charleston, South Carolina

Printed in the United States of America

Library of Congress Control Number: 2016953152

For all general information, please contact Arcadia Publishing:
Telephone 843-853-2070
Fax 843-853-0044
E-mail sales@arcadiapublishing.com
For customer service and orders:
Toll-Free 1-888-313-2665

Visit us on the Internet at www.arcadiapublishing.com

To everyone who has ever made Fosters Meadow their home.

CONTENTS

ACKNOWLEDGMENTS

This book could not have been completed without the help, support, and enthusiasm of these people: Joseph Coen of the Diocese of Brooklyn; Iris Levin of Nassau County Photograph Archive; Gerri Solomon and Victoria Aspinwall of Long Island Studies Institute; Michael Alber of NYS DOT; Christina Scali, Guy Ferrara, Jacklyn Kunz, James Borzumato, Amy Bentley, Joan Diamond, Barbara Abrams Buscemi, and Karen Selah from Valley Stream Historical Society; Trustee Kathy Sharkey, Mayor Geoffrey Prime, Trustee Elton McCabe, and Marlene Melendez from South Floral Park; Ann English, Fred Kress, and Irnel Stephen from Rosedale Civic; Frank Marino and Mara Marin of Elmont Memorial Library; Mayor Edwin Fare and Trustee Vincent Grasso of Valley Stream; Erik Huber of Queens Library; Claudine Hall and William Garnett of Jamaica Square Improvement League; Patrick Nicolosi of East End Civic; Sandra Smith of Elmont Coalition for Sustainable Development; Beverley Barr of St. John's Methodist Church; Michael Capoziello and Ralph Esposito from the Elmont Fire Department; Nick Ciccone of the *Long Island Herald*; Officer Steven Zacchia of Nassau County Police Museum; Patricia Johnson and Joy Edwards of St. Vincent de Paul Church; Loucia Rodrigues-Whyte and Kenneth Findlay of American Legion Post 1033; Pat Boyle of Gateway Youth Outreach; Paul Van Wie of Franklin Square Historical Society; Albert Schmitt; Hap Boening; Ann DeMichael; Amanda Laikin; Cristina Brennan; Legislator Vincent Muscarella; Joseph Nocella; Mary Cirillo; Maryola Dannebaum; Assemblywoman Michaelle Solages; John Logerfo; Councilman Edward Ambrosino; Douglas Mashkow; Douglas Pascarella; Janet Harvey; Jean Kohler; Carol Grassi; Joseph Foarile; Paul Sapienza; Thomas Rinaldi; Ken Nebel; Russ Van Deinse; Kim Collins; Brian Nevin; Nick Famiglietti; Michael E. Florio; my parents, William F. Florio and Cathy Florio; and my title manager, Caitrin Cunningham.

INTRODUCTION

The plains and salt marshes that made up Elmont, Rosedale, and their surrounding areas started to attract English and Dutch farmers in the 17th century. Christopher Foster, born in England in 1603, made his first trip to America with his wife and son George in the 1620s, but soon returned to England after his wife died. In 1628, Foster remarried to Frances, a young daughter of a Presbyterian minister, and had three more children—Rebecca (born in 1630), Nathaniel (born in 1633), and John (born in 1634). Foster returned to America with his family in 1635, landing near Boston. He settled in Lynn, Massachusetts, in 1638. Then, in 1647, Foster moved on to the west meadow of the Hempstead Plains with his brother Thomas, and the area became known as Fosters Meadow, encompassing present-day Elmont, North Valley Stream, Rosedale, Laurelton, Cambria Heights, Franklin Square, South Floral Park, Springfield Gardens, parts of Valley Stream, and Floral Park; it also influenced the development of Queens Village, St. Albans, and New Hyde Park. In 1651, Christopher moved to Southampton, New York, where he became active in politics and was elected a townsman and constable in 1660. He also had four more children—Benjamin, Hannah, Joseph, and Sarah. Christopher died at age 84 in 1687. His descendants still live in the Southampton area, and some are still active in civic affairs.

Thomas Foster, William Foster, and another Foster brother stayed in Fosters Meadow, along with Christopher's son John, and farmed the land bordering Simonson's Creek (also known as the Fosters Meadow River). Thomas was elected to the town board in 1659.

The Fosters and many early settlers were devout Presbyterians. Dutch farmers started to move to the area soon after the Fosters, bringing with them the traditions of the Dutch Reformed Church. They were welcomed by the predominantly English and Presbyterian community, setting the precedent for future immigration to the area. Among the new Dutch settlers were the Hendricksons, whose patriarch, Garrit Hendrickson, came to America around 1648 and moved to Fosters Meadow around 1670. By 1698, Harman Hendrickson had solidified Fosters Meadow as the home base for the Hendricksons and their long line of descendants.

Other early settlers of Fosters Meadow include the Mounts, the Kinseys, the Baylises, the Smiths, the Riders, the Nostrands, the Bedells, the Baisleys, the Skidmores, the Carmans, the Irelands, the Jacksons, the Frosts, the Mayles (sometimes Meale), the Johnsons, the Remsens, the Carpenters, the Ludlums, the Burtises, the Coverts, the DeMotts, the Corcorans, the Lawrences, the Dunsburys, and the Higbys (sometimes changed to Higbie or Higbee); the Higby patriarch, British captain Edward Higby, came to Fosters Meadow from Jamaica in 1661 and settled along what is now Merrick Road and Springfield Boulevard.

Soon after the Township of Greater Jamaica was granted a patent in 1656, more farmers began moving south toward the salt marshes of present-day Rosedale and Springfield. They called this area the "Spring Field" due to its fertile open meadowlands. An early "highway" was cut from Jamaica to Spring Field in the 1660s; this followed the present-day route of Merrick Boulevard. Any farmer who wanted farmland in the area was required to clear and lay out the right-of-way for the road. Farmers started building dams for waterwheels on the many streams, creating ponds. Joseph Carpenter and Caleb Carman built a gristmill and a sawmill on Springfield Road (now Springfield Boulevard) in the location where it would meet the future South Conduit Road. Derrick Amberman built a gristmill near the corner of Fosters Meadow Road (Brookville Boulevard) and Cherry Lane (147th Avenue) on the Old Mill Creek around the time of the American Revolution, creating what is now Conselyea Pond. The gristmill was still in use as recently as 1859.

Around 1670, Springfield Cemetery was established on Springfield Road north of most of the settlements. On February 14, 1737, Dutch Reformed Church members purchased land to be used

as a burial ground in the eastern part of Fosters Meadow on Fosters Meadow Road. The cemetery was exclusively for Dutch Reformed Church members. Dutch Reformed residents of Jamaica and Newtown are buried there as well. The land was part of the Van Nostrand farm and was called Fosters Meadow Cemetery. It was later renamed Elmont Cemetery. Both of these cemeteries still exist today, surrounded by newer cemeteries (Montefiore and Beth David, respectively).

By 1722, the population of Fosters Meadow had grown to 1,722 freemen and 319 slaves. In 1721, local farmers built a Presbyterian meetinghouse on Fosters Meadow Road (Elmont Road).

The American Revolution split Fosters Meadow in two. After the Battle of Long Island, British soldiers occupied the area (including many farmers' houses). The British took over farms to feed their troops and tore down churches to build barracks. After a Presbyterian church was torn down in Hempstead for barracks, the congregation traveled to the Presbyterian church in Fosters Meadow for services. The British army band followed the flock and loudly played music outside during sermons (this did not stop the parishioners, as the priest just waited until the British tired themselves out and went away). Finally, in an act of revenge, the British tore down the Fosters Meadow Presbyterian Church (the church may have been named St. Paul's) in 1778 and used the wood to build barracks in Hempstead.

Many families in Fosters Meadow were divided over which side to take in the American Revolution. Solomon Foster was a well-known Tory, or Loyalist. The Hendrickson family split in two (after the Revolution, the Tory members moved to Canada). Patriots murdered Samuel Doughty because he was a known Loyalist. Other Loyalists included George Ryderson, David Golden, Thomas Cornell, Capt. Richard Hewlett, Joshua Mills, and Isaac Smith. Many Tories acted as spies and robbers for the British army. Ten Patriot militia units were formed from Queens County, including one from Fosters Meadow under Capt. John Skidmore. Their ranks included Derrick and Cornelius Amberman; Isaac, Nemehiah, Daniel, and John Bayles; Samuel, Joseph, and Thomas Higbie; Hendrick, Aaron, and Abraham Hendrickson; William, Nehemiah, and Nathanial Ludlum; David and Waters Lambertson; Andrew Mills; Uris and Stephen Rider; Richard and Nathaniel Walter; Daniel Skidmore; and Increase and Nehemiah Carpenter. They fought minor skirmishes against the Tory farmers. In 1777, Patriot farmers in Queens County joined together under Derrick Amberman to form an underground resistance movement against the British army. They attempted to starve the British out by withholding crops from them. This backfired when the British commandeered all crops, regardless of how much was left for the farmers. Joshua Mills reported Amberman's plan to British major Richard Witham Stockton of His Majesty's Sixth Battalion of New Jersey Volunteers (first cousin of the signer of the Declaration of Independence with the same name). Stockton decided to make an example of Amberman and scare the rest of the farmers into submission. Along with Capt. Eyre Evans Crowe, he ordered British troops to raid Amberman's mill and drag him out into the street, in full view of the other farmers of Fosters Meadow. Stockton tied him to a tree on the corner of Cherry Lane and Fosters Meadow Road and whipped him until he passed out. He then ran him through with his sword a number of times.

Stockton was court-martialed by British High Command in Bedford, Brooklyn, for fear of an uprising of Fosters Meadow farmers. He was acquitted at his trial and escaped to St. John, New Brunswick, after the war. Amberman's widow, Sarah, sold the gristmill to the Conselyea family, who ran it until the mid-19th century.

In 1830, new Methodist settlers started to meet and hold services and Sunday school in the home of Isaac L. Wright. In November 1840, John Baylis donated land for a Fosters Meadow Methodist church. This became St. John's Methodist Church, which is still standing. Records show another Methodist meetinghouse being built in the area in 1836, but no documents beyond that exist, and it seems to have disappeared by 1852.

The marshy area by Hook Creek was known as Hungry Harbor and was home to many squatter communities. It also acted as a port for farmers who wanted to ship goods via water. John Smith originally bought the land at Hungry Harbor in 1643, and over time, boats started docking at the "port," bringing coal and fertilizer and salt hay. Farmers used the dock and the network of creeks to

ship supplies to Manhattan. Rowboats anchored with squatters and fisherman catching flounder and clams and crabs were a common sight in the Hungry Harbor area. The Hirst brothers took over the dock at some point in the 1800s. They also ran a soap factory nearby, where they made a huge profit buying diseased hogs at a low cost and turning them into soap. Eventually, when the black measles that had been killing the hogs died out, the Hirst's soap empire washed away.

The city of Brooklyn needed a better water supply and officials decided to pump water in from reservoirs located in the towns of Hempstead and Jamaica via a conduit. In 1858, the Nassau Water Works Company (later the Brooklyn Water Works Company) purchased the water rights to Simmon's Mill and Pond, which diverted water from Conselyea Pond and Cornell Pond. Simmon's Pond was at the intersection of the Merrick to Jamaica Plank Road and Fosters Meadow Road. The Nassau Water Works Company cleaned out the pond and turned it into a branch reservoir called the Twin Ponds. The Twin Ponds were drained in 1933, when the Laurelton branch of the Interborough Parkway was constructed. Following the Civil War, in 1868, a single-lane road called Water Works Conduit Road was constructed over the Nassau Water Works Company's conduit pipeline. This evolved into the six-lane North and South Conduit Avenues and Sunrise Highway after the roadway was widened in 1946.

Around 1840, German Catholic farmers began moving to Fosters Meadow from Middle Village and Winfield, Queens. This influx of Germans once again changed the ethnic makeup of Fosters Meadow and made Catholicism the primary religion of the area. Philip Hoeffner was one of the first new German settlers in the area, followed by the families of Wilhelm Finn, Bernard Rottkamp, Franz and Joseph Hartmann, Andreas Kraus, Joseph Roeckel, Jacob Felton, Franz Hage, Johan Krug, John Dubon, Franz Ridder, Joseph Hoffmann, Freidrich Reisert, Henry Raberding, Philip Barb, George Ruhl, Nicklaus Kreischer, John Hauck, Herman Sappelt, Heinrich Zimmer, Anton and Simon Krummenacker, John and Johann Herman, Henry Schmitt, Jacob Stattel, Franz Froehlich, John Marz (later March), Henry Kiesel, Frank Wulforst, John Peter Rath, George Hummel, John Seufert, John Hatt, Heinrich Zimmermann, and the Gunther, Goeller, Muller, Erb, Kappelmeier, Richter, Reising, Keller, Meier, Krapf, Kalb, Boening, Kiefer, Recter, Becker, Decker, Robrecht, and Christ families.

Many of these German Catholic farmers were traveling back to their home congregations in Middle Village to attend Sunday religious services. In 1852, Joseph and Carolina Hoffmann allowed Catholic services to be held in their farmhouse on the west side of Fosters Meadow Road, just south of today's Dutch Broadway. The parlor was blessed as the Oratory of St. Lawrence on August 10, 1852 (the Feast Day of St. Lawrence). In 1854, a small church was erected on Fosters Meadow Road near Central Avenue (today's Linden Boulevard) and named the Church of the Nativity of Our Lord, and a cemetery was established around it. In 1857, the church changed its name to St. Boniface, honoring the patron saint of Germany. A school opened in the basement of the church in 1857. The Hartmann family sold three acres of land on the east side of Fosters Meadow Road in 1868 for a new church and cemetery. On August 15, 1869, work on the new St. Boniface German Catholic Church began.

Lutheranism also appeared in Fosters Meadow with the German farmers. While many were Catholic, some of the immigrants came from Protestant areas of Germany and brought their Lutheran religion with them. Originally, a preacher from East New York would perform Lutheran services at different houses and hotels on Fosters Meadow Road for the parishioners. On March 28, 1864, the cornerstone was laid for the German Evangelical Lutheran Church on the east side of Fosters Meadow Road on land donated by Johann Seufort. A cemetery was eventually established next to it. Though it was created as a Lutheran church, by the late 1860s, the church became affiliated with the Nassau Presbytery and became St. Paul's German Presbyterian Church. Services were held completely in German until Rev. Augustus C. Espach started introducing English into the Mass in 1903. In 1904, a new St. Paul's German Presbyterian Church was constructed.

The South Side Rail Road came through Fosters Meadow in May 1870, when the Fosters Meadow station appeared on timetables. The station was on present-day Hook Creek Boulevard and Sunrise Highway. A station building was constructed between June and July in 1871, but it

was abandoned in 1889. A new station was built that year, and in 1892, it was renamed Rosedale Station. Also in the 1870s, Springfield Station opened on Merrick Boulevard. It moved to the southeast side of Springfield Boulevard in 1885. A Higbie Avenue/Springfield Station opened in 1908, and a Laurelton/Central Avenue Station opened in 1907. The New York, Jamaica to Far Rockaway Railroad line built tracks in 1871 running through today's Brookville Park, over Conselyea Pond, between Edgemere and Huxley Avenues, through the cinder ravine, and over Hook Creek to Cedarhurst Station. This was known as the Cedarhurst Cutoff. The line was used on and off for a number of years and was finally abandoned in 1934.

In 1882, northern Fosters Meadow established a post office in J.R. Burtis's store on Hempstead Turnpike and needed to select a new name. Sarah Frances Ludlum Hendrickson, wife of Townsend Coles Hendrickson, suggested the name Elmont. (Other choices in the running were Farmer's Valley and Belle Font.) Elmont won with 22 votes (Belle Font received 7 votes). In 1894, southern Fosters Meadow took the name Rosedale. Two competing real estate companies were surveying the land for development. Standard Land Company, of Long Island, favored the name Rosedale, and T.V. Archer and Sons of Jamaica favored Brookville. Since Brookville was already the name of an area in the town of Oyster Bay, Rosedale was chosen. The Fosters Meadow name was used informally and on maps for a few years after the name change, referring to North and West Valley Stream and the area around Twin Ponds.

From the end of the 19th century until World War II, Italian, Irish, and Jewish immigrants started moving to Elmont and Rosedale, again changing its demographics. The areas started to be developed with suburban housing. The Springfield Gardens development went up in 1906. Cambria Heights, Laurelton, Rosedale, and Elmont developed new housing in the 1920s and again after World War II. By the 1950s, there was more suburban housing in Fosters Meadow than farms. Demographics changed again in the 1970s, when immigrants from the Caribbean and Central America started moving into the area, and many of the old German, Dutch, English, Italian, Irish, and Jewish residents left. Even more recently, influxes of Indian and Pakistani immigrants are set to change the demographics again. Recently, an Indian Syro-Malankara Eastern Catholic church and the Masjid Hamza Islamic Center and Mosque have established themselves in the Fosters Meadow area. Since the time of Christopher Foster, the Fosters Meadow community has changed drastically through both the ethnicities of its residents and its agricultural usage, and it continues to evolve today.

One

FOSTERS MEADOW AND EARLY ELMONT

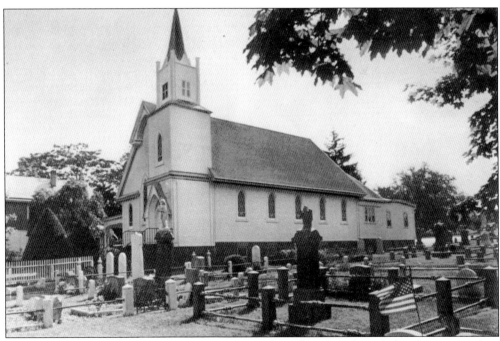

Immigrants from northern Germany were primarily Lutheran and needed a place to worship. In December 1864, a German Evangelical Lutheran church opened on land donated by Johann Seufort. It joined the Nassau Presbytery and became St. Paul's German Presbyterian Church in the late 1860s. The pictured church replaced the original church in 1904. It still stands and is now called the Elmont Presbyterian Church. (Elmont Memorial Library.)

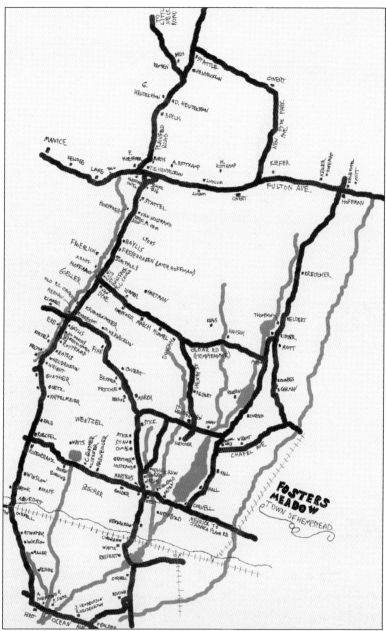

The eastern half of Fosters Meadow was in the town of Hempstead and consisted of Elmont, North Valley Stream, South Floral Park, and parts of Valley Stream, Floral Park, and Franklin Square—influencing the development of New Hyde Park and West Hempstead. This map shows the location of many of the farmers in Fosters Meadow from 1850 to 1920 and also some of the original roads. Fulton Avenue is now Hempstead Turnpike, Cedar Road/Hempstead Avenue is now Dutch Broadway, Fosters Meadow Road is now Elmont Road, Henry Street is now North Fletcher Avenue, New Hyde Park Avenue is now Covert Avenue, Chapel Avenue is now Wheeler Avenue, Central Avenue is now Linden Boulevard, Ocean Avenue was once the name of both Hook Creek Boulevard and Rosedale Road, Little Neck Road is now Little Neck Parkway, and Merrick to Jamaica Plank Road is now Merrick Road. (Author's collection.)

12

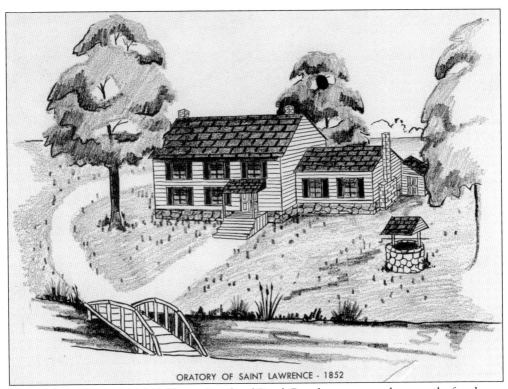

ORATORY OF SAINT LAWRENCE - 1852

The northwest corner of today's Elmont Road and Dutch Broadway was once home to the farmhouse of Joseph Hoffman, whose parlor was used by the Roman Catholic German immigrants of Fosters Meadow as the Oratory of St. Lawrence, their first local place of worship. (It was dedicated on the Feast Day of St. Lawrence on August 10, 1852.) In 1854, the Church of the Nativity of Our Lord was established south of the oratory on Elmont Road, near present-day Linden Boulevard, along with a rectory and cemetery. In 1857, the church changed its name to St. Boniface, the patron saint of Germany. It moved to the northeast corner of Elmont Road and Dutch Broadway in the following decade. (Both, Elmont Memorial Library.)

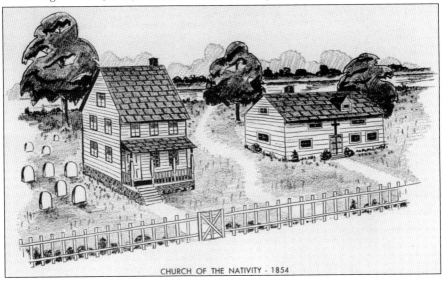

CHURCH OF THE NATIVITY - 1854

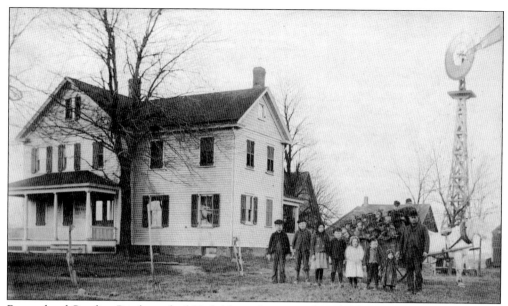

Bernard and Caroline Rottkamp had 10 children who survived to adulthood and 103 grandchildren. Two of their children, Anton and Henry (later followed by their children Anthony and John), farmed land in Elmont on Hempstead Turnpike between Jamaica Square and Covert Avenue starting in 1892. This photograph shows Anton Rottkamp and his family in front of their Elmont farmhouse. (Elmont Memorial Library.)

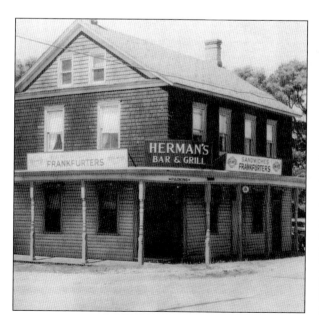

John Maxmillian Herman ran Herman's Hotel (later Herman's Bar & Grill) on the corner of Fosters Meadow Road (Elmont Road) and Central Avenue (Linden Boulevard). The hotel was opened in the 1880s by Johann Herman. Simonson's Creek (also known as the Fosters Meadow River) ran under the building, and Herman used to chill his beer in the waters. John M. Herman was also the Democratic leader in Elmont and used the bar as the club's meeting space. This photograph is from the 1940s. Jacob Herman, son of John, took over Herman's Bar & Grill until his death in 1953. His father, John, died in 1955. (Albert Schmitt.)

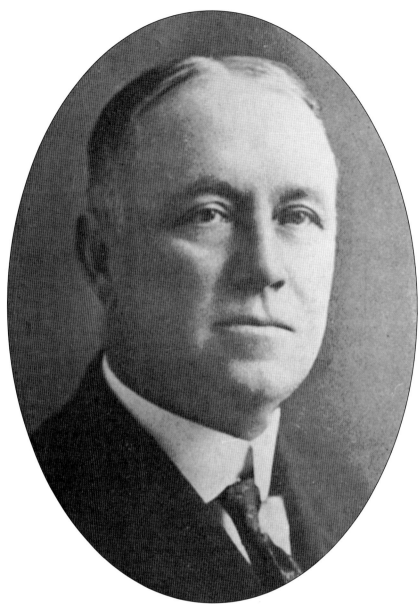

On January 1, 1898, what is often referred to as the City of Greater New York was formed, incorporating the Queens County town of Jamaica and the western half of Fosters Meadow. Nassau County was formed the following year from the eastern half of Queens County. When the city line was drawn, a large portion of the town of Hempstead, from Floral Park down to the Atlantic Ocean, was included in the city limits, including parts of Inwood, Cedarhurst, Lawrence, Valley Stream, Far Rockaway, Elmont, and Floral Park (the line goes through the intersection of Elmont Road and Hempstead Turnpike and heads south through today's Arthur J. Hendrickson Park.) Assemblyman Wilbur Doughty (pictured) of Inwood successfully persuaded the New York State Assembly to redraw the line to the former town of Hempstead boundaries, minus Far Rockaway and the Rockaway Peninsula, on February 25, 1899. The returned land became known as the Doughty Strip. Doughty later became supervisor of Hempstead Town. (Nassau County Photograph Archive.)

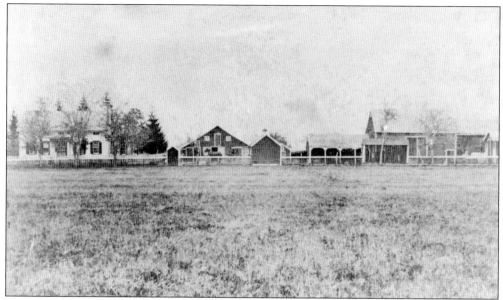

This 1885 photograph shows the homestead farm of Daniel Rapelje Hendrickson Sr. on the Hempstead to Jamaica Plank Road. The Hendrickson family were some of the earliest settlers in the Fosters Meadow area; Harman Hendrickson and his wife, Margaret, are shown on the Hempstead census in 1698. The family is still prominent in Nassau County, with two members having served as mayor of Valley Stream. (Queens Borough Public Library, Archives, Illustrations Collection–Elmont.)

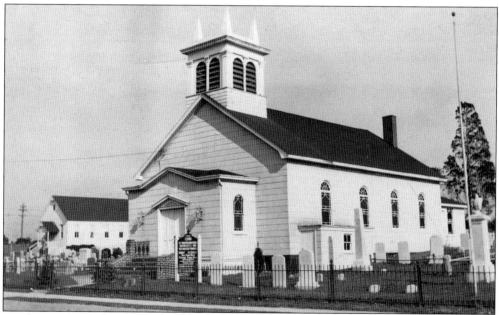

Methodist settlers in Fosters Meadow started holding services and Sunday school in the old Fosters Meadow schoolhouse in 1830 and later in the home of Isaac L. Wright. In November 1840, John Baylis donated land on Fosters Meadow Road to the Christian Society for a new Methodist church called the Fosters Meadow Church. That church became St. John's Methodist Church. (Author's collection.)

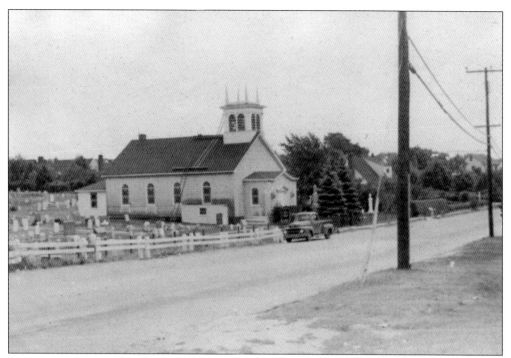

For a time, the stretch of today's Elmont Road in front of St. John's Methodist Church and cemetery was 241st Street. When the Laurelton Parkway was built, 241st Street was eliminated and became part of Elmont Road. The old church building is now the Parish Resource Center. (St. John's United Methodist Church.)

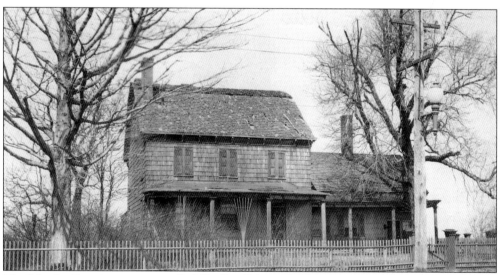

The John Ludlum (sometimes spelled "Ludlam") house and farm was established in 1798 on the north side of Hempstead Turnpike, west of Benson Avenue. The Rottkamp property surrounded the Ludlum farm. After owning the property for close to 130 years, the Ludlum family sold it in 1925. (Elmont Memorial Library.)

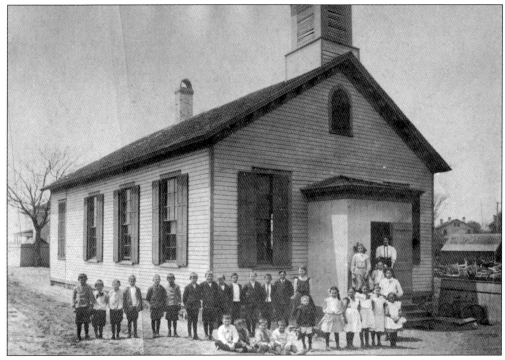

Prior to 1860, the only school in Elmont was in the basement of St. Boniface Church. In 1860, a one-room schoolhouse for District 16 was built on Hempstead Turnpike near the northwest corner of Plainfield Road. After the Civil War, this new one-room schoolhouse was built on School Street. It was in use until 1908. Afterward, students were taught in the back room of J.S. Baylis's General Store and at the firehouse. (Elmont Memorial Library.)

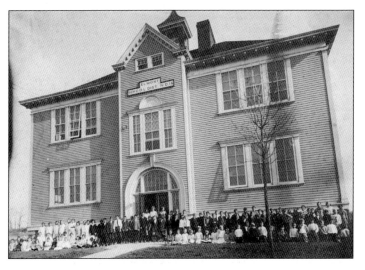

Additions were made to the 1908 firehouse school on Elmont Road and Atherton Avenue after World War I. The new eight-room District 16 schoolhouse opened in 1922. Covert Avenue School was built in 1925 and Belmont Boulevard (Clara H. Carlson) School was built in 1930 to alleviate overcrowding. (Queens Borough Public Library, Archives, Illustrations Collection–Elmont.)

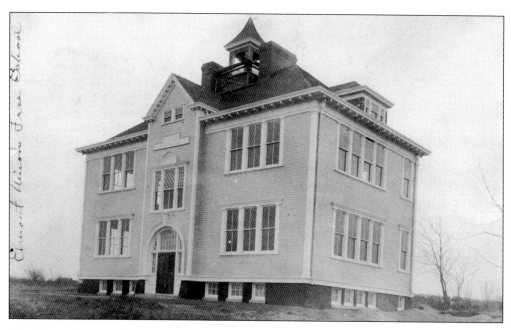

The above photograph shows the 1908 "firehouse" District 16 school at the corner of Elmont Road and Atherton Avenue after alterations. In 1922, a new school building was erected in front of this structure to connect the old and new schools. The below photograph, an overhead view of Elmont Road and Atherton Avenue in the 1950s, shows the new school addition connecting to the old building. The Belmont Hook and Ladder firehouse is in the lower right of the photograph. The school building is still in use as the Elmont School District administrative building. (Both, Michael Capoziello.)

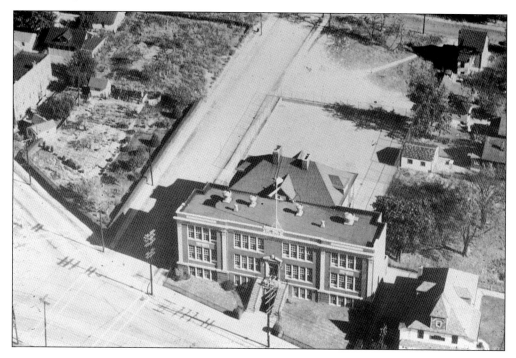

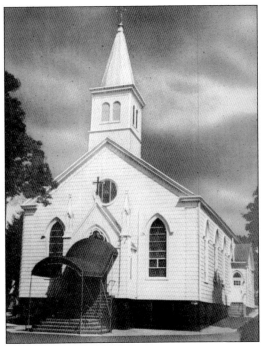

The cornerstone for the new St. Boniface German Catholic Church, located on the northeast corner of Elmont Road and Dutch Broadway, was laid on the Feast of the Assumption on August 15, 1869. Fr. Joseph Hauber bought the property from the Hartmann family in 1868. Funds for this new church were raised by a committee consisting of Joseph Rath, Frank Froehlich, Andrew Batt, Christian Ziegler, Jacob Stattel, Peter Rath, Joseph Hoffman, Phillip Hoeffner, and Jacob Feltman. The church was expanded in 1889. On May 16, 1916, forty-nine deceased parishioners were moved from the old cemetery on the west side of Elmont Road near Linden Boulevard and placed in a common grave in the new cemetery. Their names are lost to time. The photograph at left shows St. Boniface around 1900. The below image shows the church, rectory, convent, school, and cemetery. (Both, Elmont Memorial Library.)

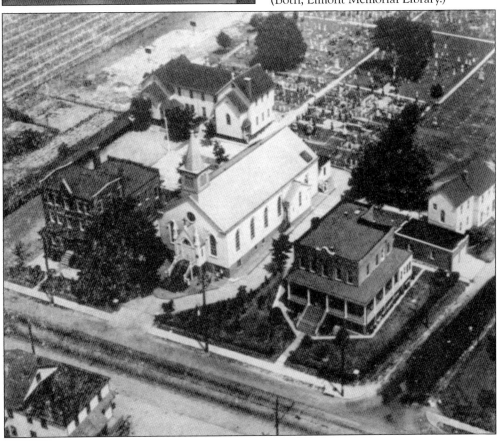

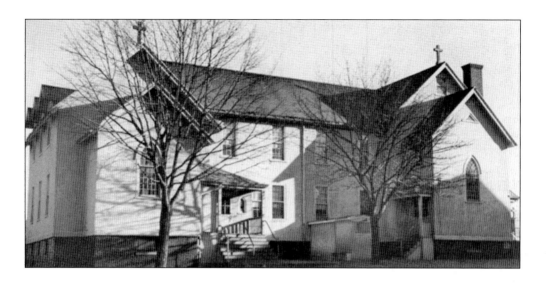

St. Boniface's school began in the basement of the Church of the Nativity of Our Lord in October 1857. Friedrich Wilhelm Geram was the teacher of its 80 children. It is the oldest Catholic school on Long Island. When St. Boniface moved to its new location, the school moved into its basement. In 1887, the two-story schoolhouse shown above was built for the 160 students who were under the supervision of two sisters from the Dominican Sisters of St. Dominic. The first floor contained four classrooms, and the second held an auditorium. The school was replaced in 1951 with the one in the below photograph and it was expanded in 1956. Though the school closed in 2004, the building remains. (Both, Diocese of Brooklyn.)

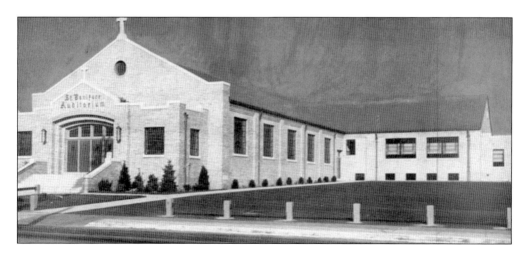

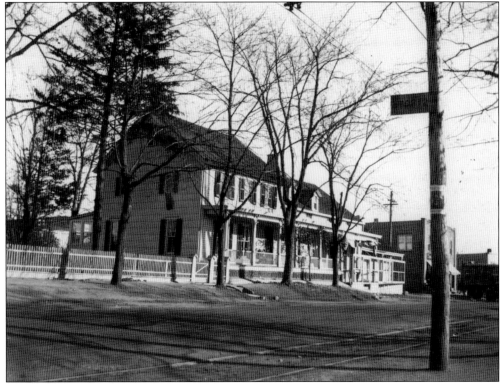

Stop 12 on the Hempstead Turnpike trolley line was J.R. Burtis's Feed & General Store, located at the northeast corner of Plainfield Avenue, and the Hoeffner Hotel, located directly across the street (between Elmont Road and Simonson's Creek). These 1922 photographs show the Burtis store (above), which was formerly the J.S. Baylis Grocery Store, a temporary schoolhouse, the post office, and where Sarah Frances Ludlum Hendrickson, wife of Townsend Coles Hendrickson, proposed the town name "Elmont" in 1882; and a roadhouse across the street (below), which might be the Hoeffner Hotel. Henry and Phillip Hoeffner ran the Hoeffner Hotel until it burned down in 1932. In 1930, it was raided by troopers for illegal gambling. (Both, Queens Borough Public Library, Archives, Eugene Armbruster Photographs.)

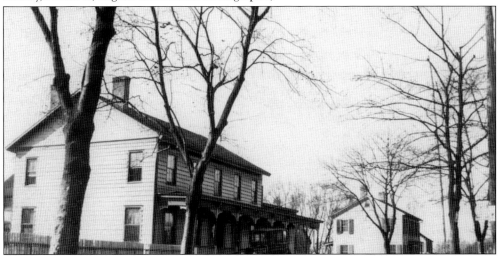

August Belmont II was the son of August Schönberg (aka August Belmont Sr.), the German immigrant founder of the Belmont Stakes (which started at Jerome Park in the Bronx.) Among Belmont II's many ventures was the Westchester Racing Association, which he organized in 1895. The association purchased the old William DeForest Manice estate in Elmont, and on May 4, 1905, opened a new racecourse called Belmont Park. The Belmont Stakes moved from Morris Park to Belmont Park that year. (Author's collection.)

William DeForest Manice built his estate, Oatlands, in 1820 on what would become Belmont Park in Elmont. The Tudor Gothic building was surrounded by 100 acres. A building on the estate called the Dolphine was a home to Louis Philippe, heir to the throne of France, while he was living in exile. (Nassau County Photograph Archive.)

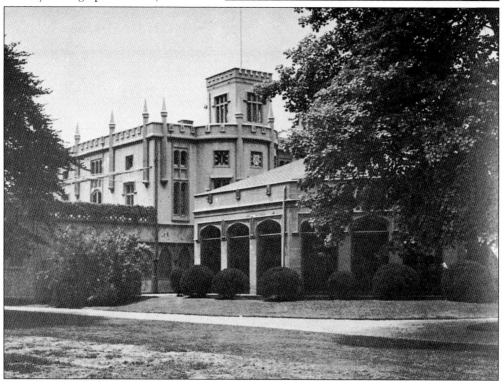

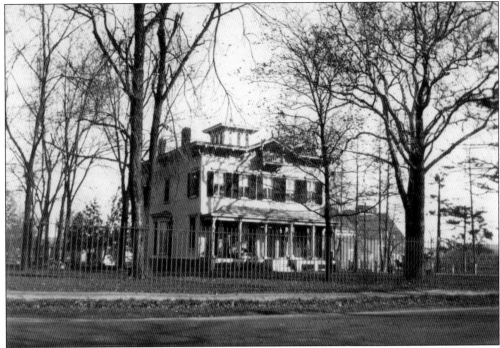

These 1922 photographs show some of the other buildings from the William DeForest Manice estate that were part of the original Belmont Park. The above image shows a building repurposed by the park opposite Waldorf Avenue, on the northeast corner of Hempstead Turnpike. The below photograph shows a house on the United Hunts Club grounds on the south side of Hempstead Turnpike (where the yellow overflow parking is today.) The Long Island Rail Road spur from Queens Village originally tunneled under Hempstead Turnpike to the south side, serving Elmont at the Hunts Club grounds. It was moved to north of the turnpike in 1957. The United Hunts Club grounds also contained a steeplechase course called Belmont Park Terminal, which ceased operation in 1927. (Both, Queens Borough Public Library, Archives, Eugene Armbruster Photographs.)

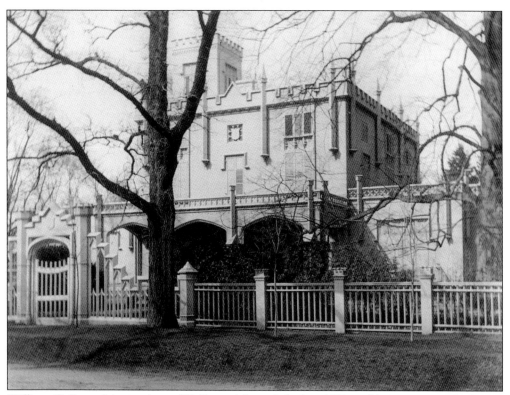

William DeForest Manice (son of DeForest Manice) died in 1903, and his estate was the last to sell to the developers of the track. The 1900 photograph above shows the mansion, which became the Turf & Field Club in the original Belmont Park (visible on the right in the 1910 photograph below). It was torn down in 1956 during renovations. The original course, a 12-furlong oval unprecedented in size and intersected by a 7-furlong straight course, initially ran races clockwise in European tradition (as shown in the photograph; that quickly ended). Inside the main course were an 11-furlong turf course and a 10-furlong steeplechase course. A training course was located east of the main course. (Above, Queens Borough Public Library, Archives, William J. Murray Photographs; below, Elmont Memorial Library.)

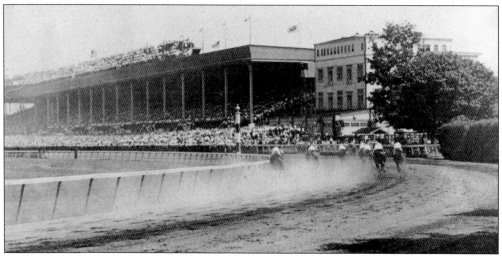

This 1914 photograph shows Hempstead Turnpike in a view looking west around the current location of Home Depot. Hempstead Turnpike was a plank road. A tollbooth sat between the Lang and Peter Hoeffner properties west of Elmont Road until 1913. The planks for the road were produced at the 1840 sawmill adjacent to J.C. Franklin's farmhouse. The trolley came down Hempstead Turnpike on May 15, 1902, and the lines were abandoned in 1926. (Queens Borough Library, Archives, Fredrick Weber Photographs.)

The Alfred E. Smith Knights of Columbus Building was the birthplace of Fr. Joseph Goeller from St. Clare's Roman Catholic Church of Rosedale. Fr. John Augustus Rath of St. Boniface purchased it from the Brisbois family and converted it into a two-room schoolhouse. It was later turned into a Knights of Columbus clubhouse. The 1878 building, at 682 Elmont Road, still stands and is now the Elmont Temple Seventh-day Adventist Church. (Elmont Memorial Library.)

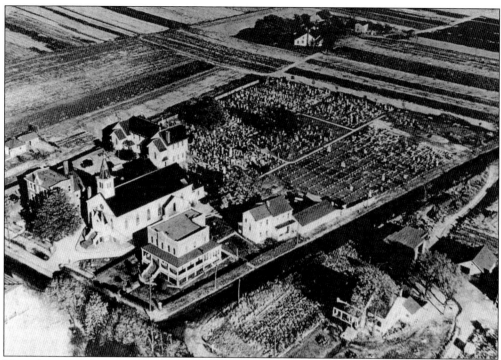

Near the top of this photograph of St. Boniface German Catholic Church is the Zimmer family farmhouse. Heinrich Zimmer and his family moved to Fosters Meadow in 1873, and he died in 1916. His son Henry married Katherine Hartmann of the neighboring farm and continued to farm the property until it was developed for Argo Village in the 1940s. In the lower right corner is property formerly owned by the Rottkamp family (and, later, the Vitranos). (Albert Schmitt.)

THE DEDICATION

1857

St. Boniface's Cath. Church at Fosters Meadow

Will take place by the Right Rev. Bishop LOUGHLIN,

Sunday, October 11, at 11 o'clock A. M.,

The Rev. Father WENINGER, Missionary, will preach on the occasion.

THE CARS WILL LEAVE FOR JAMAICA:

the Station Bedford at 9½, and East-New-York 9 35 A. M.

If the day appointed should prove rainy, the Dedication will take place on the next following Sunday.

TICKETS 50 CENTS.

In 1857, the Church of the Nativity of Our Lord changed its name to St. Boniface German Catholic Church. This ticket for the dedication was distributed to parishioners. Bishop John Loughlin, of the Diocese of Brooklyn, oversaw the dedication of the church, and missionary priest Father Weninger spoke during the occasion on October 11. (Diocese of Brooklyn.)

Caroline Froehlich was 88—and the oldest living parishioner at St. Boniface German Catholic Church—when this photograph was taken. She was born to Franz and Magdalena Froehlich after they moved to Fosters Meadow in 1863. She married Henry Wulforst on February 26, 1889, at St. Boniface, and died on March 8, 1926. (Diocese of Brooklyn.)

Rev. Joseph Hauber served as pastor of St. Boniface German Catholic Church from 1868 to 1905. He started as a missionary priest and opened St. Boniface's Parochial School, the first Catholic school on Long Island. He later presided over the relocation of the church to its current site and the construction of a rectory, convent, new cemetery, and separate school building. Reverend Hauber is considered the founding pastor of St. Boniface. (Diocese of Brooklyn.)

Belmont Hook and Ladder Company No. 1 opened soon after Belmont Park (this photograph is from 1906). The company was financed by August Belmont II to protect his racetrack and still operates out of this Elmont Road firehouse. (Elmont Fire Department Historical Society.)

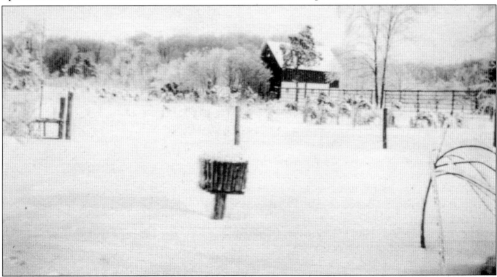

The Krapf family settled in both Elmont and Valley Stream in the early 20th century. Their farm was located on Elmont Road, near the Hoffman family farm, until the late 1920s. This photograph shows the Krapf family's Elmont farm during a snowy winter. (Jean Kohler.)

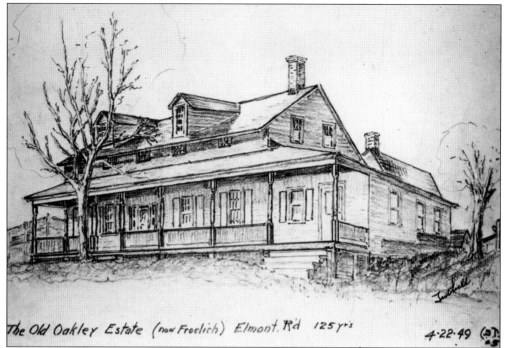

The Old Oakley Estate (now Froelich) Elmont. Rd 125 yrs 4·22·49

The Froehlich Farm was located on the west side of Simonson's Creek, straddling today's communities of Elmont and Cambria Heights, north of Linden Boulevard. Franz Froehlich came from Germany with his wife, Magdalena, in the 1850s and moved to Fosters Meadow in 1863, when they purchased 31 acres from Joseph Hoffman on December 10. Part of the land near Simonson's Creek was part of the Oakley property. (Queens Borough Public Library, Archives, Cuyler Beebe Tuthill "Americana Long Island" Records.)

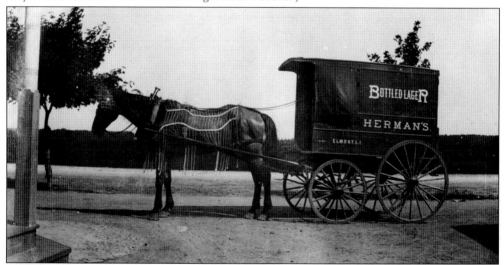

John Herman's son delivered beer to hotels and inns around the county via a wagon. This 1905 photograph shows the Herman's Hotel Beer Wagon parked outside Hausch's Hotel at Jericho Turnpike and South Ninth Street in New Hyde Park. Herman's Hotel (and later Bar and Grill) sat on the northwest corner of Elmont Road and Linden Boulevard for decades. (Nassau County Photograph Archive.)

Two

ELMONT, NORTH VALLEY STREAM, AND SOUTH FLORAL PARK

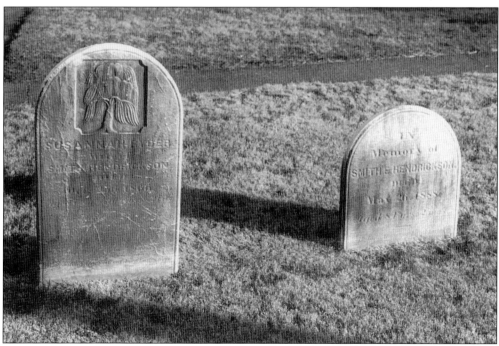

Smith Hendrickson's gravestone sits in the St. John's Methodist Church cemetery with those of many other members of the Hendrickson family. Smith was the superintendent of Sunday school at St. John's and a prominent member of the Elmont community. The church and cemetery are located in the Alden Terrace section of North Valley Stream. (Elmont Memorial Library.)

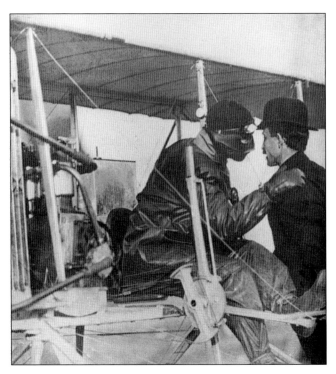

Gambling and horse racing were banned in New York State between 1910 and 1912. Belmont Park turned to aviation tournaments. The First International Aviation Tournament was held at Belmont Park from October 22 to 31, 1910, and overseen by the Wright brothers and Glenn Curtiss. The tournament featured numerous contests, including speed contests (the Gordon Bennett Trophy Race), a $10,000 race to the Statue of Liberty, and a $5,000 altitude race. Ralph Johnstone, flying for the Wright brothers, broke an altitude record. This photograph shows Johnstone conferring with Orville Wright before the start of the race. (Nassau County Photograph Archive.)

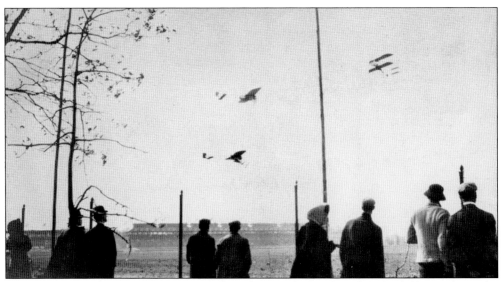

This photograph shows spectators, including the Wright brothers (on the left), watching the tournament. Johnstone and Arch Hoxsey were known as the Heavenly Twins. Claude Grahame-White won the $5,000 Gordon Bennett Trophy Race. (Nassau County Photograph Archive.)

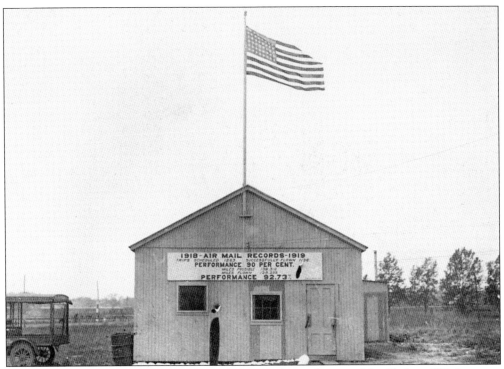

In 1918, the Post Office Department opened an airmail route between New York and Washington, DC. Belmont Park served as the original New York terminal, as shown in this photograph. The operation was later moved to Roosevelt Field. (Nassau County Photograph Archive.)

After gambling was reinstated in New York, horse racing returned to Belmont Park. This photograph shows the Belmont Park Terminal steeplechase grounds at the United Hunts Club on the south side of Hempstead Turnpike. This area is now an overflow-parking field. (Nassau County Photograph Archive.)

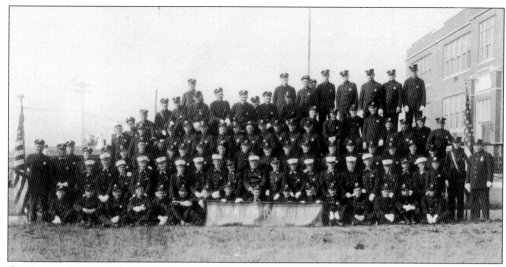

On August 20, 1928, the five independent fire companies in Elmont formed a unified fire district. Five new trucks for these departments were dedicated on September 2, 1929. This group photograph was taken at Covert Avenue School. (Elmont Fire Department Historical Society.)

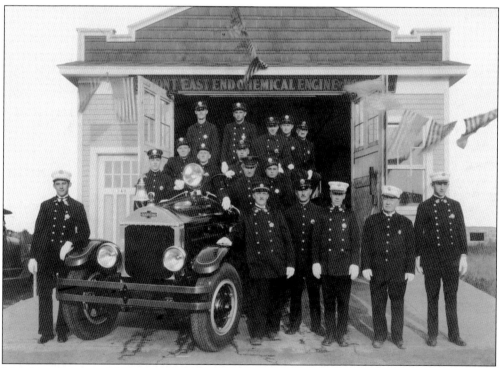

Meacham Avenue and Elmont's East End finally got fire protection in 1924, when the Elmont East End Chemical and Engine Company No. 3 formed. In this September 2, 1929, photograph, the members of the company pose with their new 1929 American LaFrance engine. A newer firehouse was built next door, but the old firehouse is still standing. (Elmont Fire Department Historical Society.)

Despite the protests of August Belmont II, who was director of the Long Island Rail Road, a trolley line was laid down on Hempstead Turnpike in 1901. Stop 20 of the line was at the present-day intersection of Hempstead Turnpike and Covert Avenue, near where the Stop 20 Diner sits. The original diner was on the corner, but it was recently moved to a new building slightly farther east. The trolley lines shut down in 1926, but the diner is still there. (Elmont Memorial Library.)

Jacob Brandt's family arrived in the late 1800s and was the first Jewish family to come to Elmont. Elmont's Jewish residents had to travel to the heavily Jewish areas of Laurelton and Cambria Heights for religious services until 1951, when Temple B'Nai Israel opened on Elmont Road. In 1917, Beth David Jewish Cemetery opened on a large piece of land previously owned by the Nostrand family. Comedian Andy Kaufman is buried there. (Author's collection.)

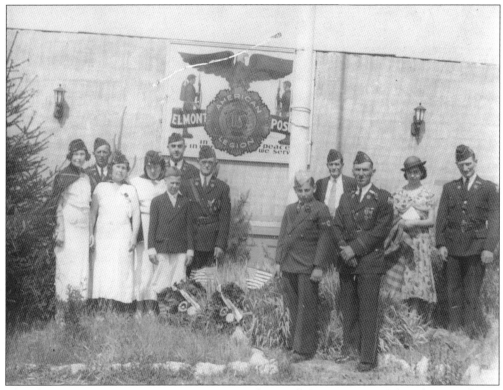

The Elmont American Legion Post 1033 opened on Hill Street in 1931. This photograph was taken in front of the Legion Hall right after a Memorial Day church service held on May 24, 1936. The current Main Hall was built in 1960 and redone in 2010. (American Legion Post 1033, Elmont.)

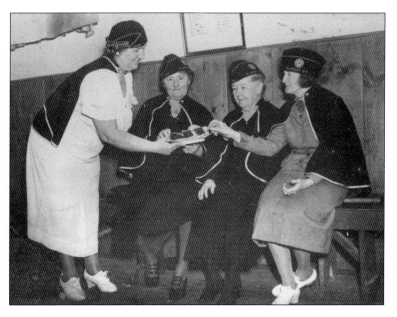

The Elmont American Legion Post 1033's Ladies Auxiliary started in 1930. This photograph from May 9, 1938, is from the Mother's Day program held in the Legion Hall on Hill Street. (American Legion Post 1033, Elmont.)

In the above photograph, the Ladies Auxiliary of the Elmont American Legion Post 1033 poses for a picture in front of the honor roll in the "dugout" of the Hill Street building. Below, a larger honor roll stands on Hempstead Turnpike honoring those who served in World War II. The honor roll's location was around where the Elmont Memorial Library is now located. (Both, Elmont Memorial Library.)

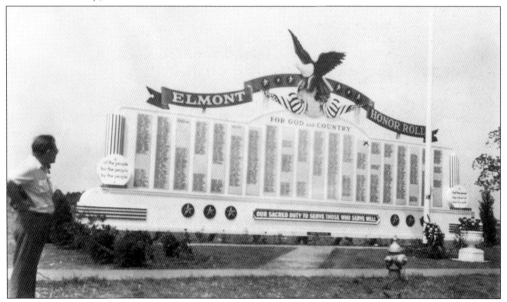

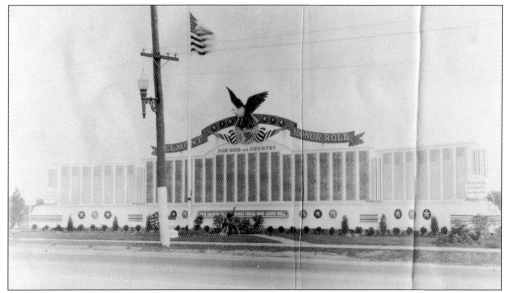

The Elmont Honor Roll on Hempstead Turnpike was expanded to include more names. The view in the below photograph looks west at Hempstead Turnpike and Franklin Street in 1949. The Elmont Honor Roll sits on the north side of the road surrounded by the Rottkamp farm. There is a mystery surrounding the Elmont Honor Roll—no one knows where it went. It disappeared without a trace sometime in the 1950s, before Alva T. Stanforth School was built on the property. Pieces of the Rottkamp farm became St. Vincent de Paul Roman Catholic Church in 1951. Great Eastern and other commercial buildings were built on another section in 1960. Today, Home Depot, Pep Boys, Applebee's, and the West Gate Stores are on the property. (Above, Elmont Memorial Library; below, Nassau County Police Museum.)

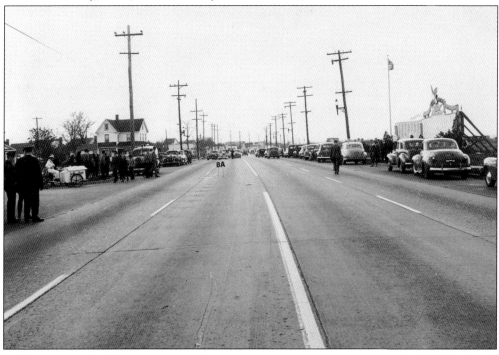

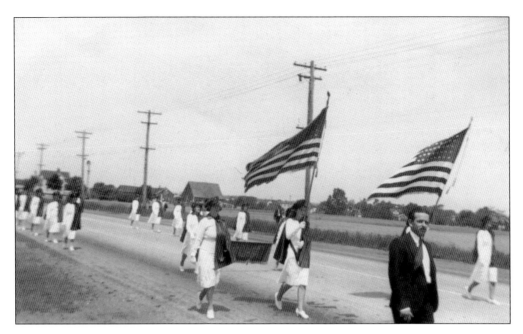

The Woman's Auxiliary marched down Hempstead Turnpike in front of the Rottkamp farm in 1943. In the background is Anton Rottkamp's farm (later Anthony Rottkamp's), and to the right of the photograph would have been Henry Rottkamp's farm (which was later partly farmed by Henry's son John Rottkamp). Anton and Henry's sisters Elizabeth and Caroline ended up marrying the sons of Franz Froehlich (Frank and George, respectively). Two other Rottkamp siblings, Anna and Bernard, married siblings of the Jacobs families. Many of the German families in Fosters Meadow intermarried with each other (the Rottkamps married into the Schmitts, Wulforsts, Mullers, Marches, and Finns). The Rottkamps sold their Elmont property in pieces and eventually moved to Glen Head. (Both, Douglas Mashkow.)

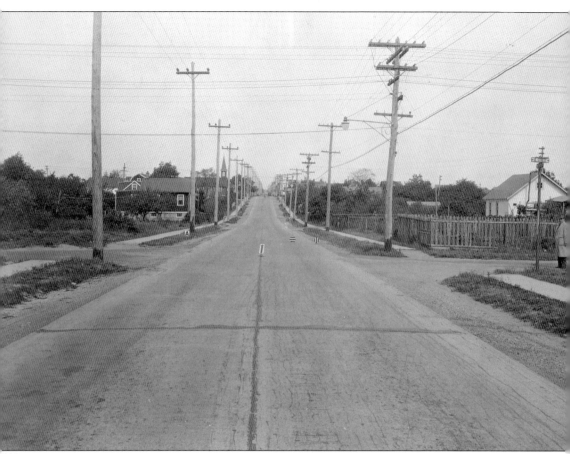

Elzey Eugene Meacham, a real estate developer from Memphis, Tennessee, was born in November 20, 1848, to Major Louis and Martha Galbreath Meacham at their estate on Union Street in the wealthy Silk Stockings Ward. He developed neighborhoods in Memphis, Louisville, and Meacham Park (in St. Louis) in 1892. It was in St. Louis that he started his practice of subdividing lots to be smaller than normal and selling them to black and ethnic white residents for cheap. He came to New York City with his son, Malcolm, and wife, Lula, between 1900 and 1903 and opened a real estate office at 15 Park Row called EE Meacham and Son. His family lived at 320 Central Park West and later at 830 Park Avenue. In 1912, he ran in the Prohibition Party for New York's 18th Congressional District, getting only 21 votes. He started developing land in the suburbs of New York, including two areas of Elmont—the Meacham Avenue corridor and the Elzey Avenue section. This 1940 photograph shows Meacham Avenue at E Street in a view looking north. (Nassau County Police Museum.)

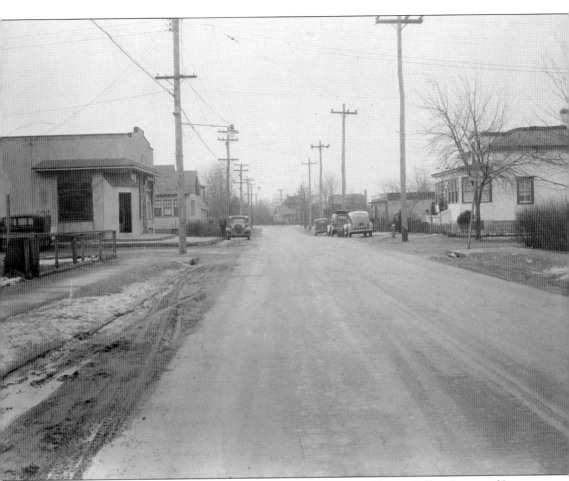

In 1920, Elzey Eugene Meacham, along with his business partner Baron Collier (owner of Luna Park), started subdividing the former John Kiefer farm in the east end of Elmont. He laid out Meacham Avenue as the main road and named many other narrow streets after popular newspapers of the time (the area is now called Newspaper Row, and it features the names of many New York newspapers along with two from Meacham's home city of Memphis). He gave away free small lots to working-class Irish and Italian immigrants, which forced them to buy the lots next to them at a high price in order to build a house. He then developed the Gotham section, building Elzey Avenue and naming other streets after popular hotels. The death of his wife, Lula, in 1920 and his son, Malcolm, in 1929 pushed Meacham to leave New York for Miami, where he died in 1931. He is buried in his family plot in Memphis. He was financially supporting three churches he built on Long Island when he died. This photograph shows Meacham Avenue at G Street in 1940. (Nassau County Police Museum.)

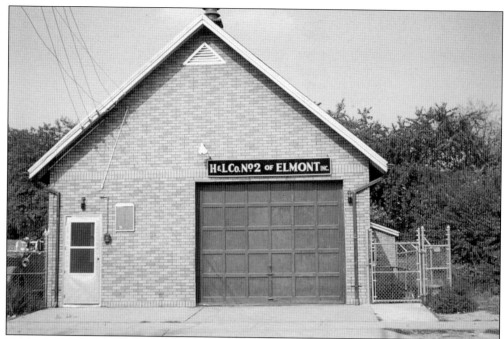

Elmont Hook and Ladder Company No. 2 was formed on Surprise Street on July 1, 1926. It was the second fire company in Elmont, but not the second fire department for the Elmont area; that was Elmont Engine and Hose Company No. 2, which served Jamaica Square and formed in 1913. (Elmont Fire Department Historical Society.)

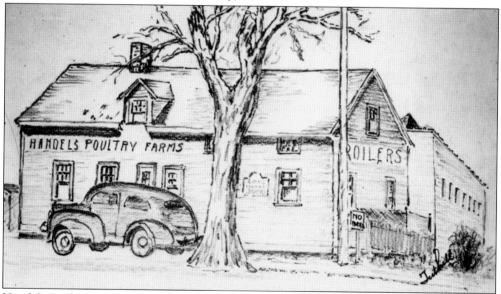

Handel's Duck Inn was a nightclub in Elmont known for its famous acts, including Rudy Vallee and comedian Joe Penner (who supposedly coined his "Wanna Buy a Duck?" one-liner there). The building caught on fire on September 20, 1932, near the end of Prohibition. Frank Nozeki, the proprietor of the inn, was arrested on federal charges after a distillery was discovered after a fire. (Queens Borough Public Library, Archives, Cuyler Beebe Tuthill "Americana Long Island" Records.)

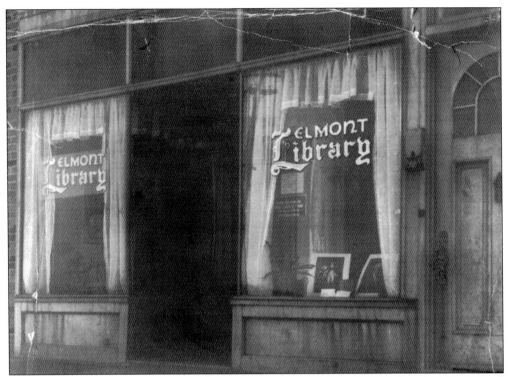

The first Elmont Library was organized in 1936 by a group of high school students in a small rented storefront at 593 Hempstead Turnpike. It was officially chartered in 1939 by the New York State Board of Regents, and five trustees were elected. In 1944, the library outgrew its location, and the trustees purchased a site on the corner of Hempstead Turnpike and Terrace Avenue (1735 Hempstead Turnpike) for a new Elmont Memorial Library. Gen. Dwight D. Eisenhower wrote a letter to the Elmont Memorial Library Association thanking them for making it a memorial to returning servicemen. It was dedicated in 1956 and expanded in 1968. In 2006, the Elmont Memorial Library moved to the former site of Alva T. Stanforth Junior High School. The second library building, shown below, is still standing and still bears its plaque honoring servicemen. (Both, Elmont Memorial Library.)

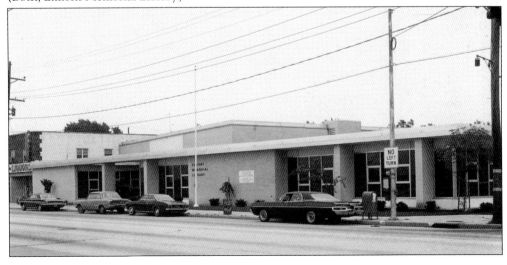

The Village of South Floral Park was incorporated in 1925 as the Village of Jamaica Square. William J. Ruppert was the first mayor. In 1931, it became the Village of South Floral Park. There was one store in the village, on the corner of Louis Avenue and Emma Street, originally run by the Rutger family and then by Joseph and Mary Foarile. It closed in 1973, and the 1928 building is now a private residence. This photograph is from the village's 50th anniversary in 1975. From left to right are Village Attorney Robert J. Pape, Trustee Joseph Ruvo, Mayor James Lorenzo, Trustee Donald P. Ferretti, Trustee Vincent DeMilia, and Trustee Alfred Summersa. (Village of South Floral Park.)

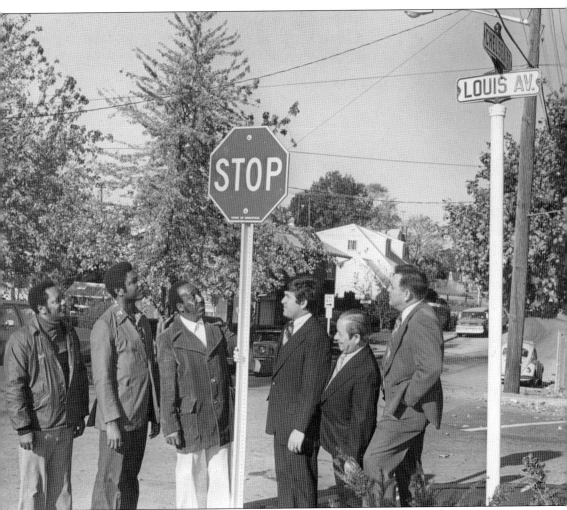

South Floral Park was one of the first integrated villages on Long Island, with black families moving there as early as 1919. In 1974, about 25 percent of the village was black or Hispanic. In 2000, it was only 22 percent white. The village elected its first Hispanic mayor, Angel Soto, in 2006, and its first black mayor, Geoffrey Prime, in 2010. (Its first black trustee was Martin Bellamy in 1980.) A new stop sign had just been erected at the corner of Louis Avenue and Chelsea Street in this 1970s photograph. From left to right are Ernest Jackson, Charles McCabe, unidentified, Hempstead Town councilman Joseph Cairo, Mayor James Lorenzo, and Trustee Andrew Russac. (Village of South Floral Park.)

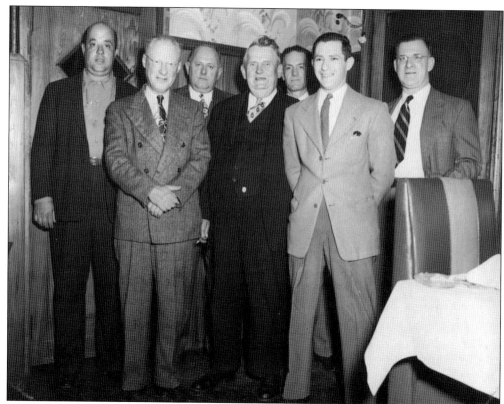

The South Floral Park Fire Department was formed as the Jamaica Square Chemical & Hose Company No. 3 (it followed the numbers of the Elmont Fire Department, which it did not join). Its original firehouse was located on the corner of Bertha Street and Roquette Avenue, and Fredrick Kasslick was the first chief. The fire garage and meeting room were moved to Roquette Avenue in 1930. Both of these photographs are from the 1942 installation. Above are, from left to right, Barney Strup, Edward Smith, George Husing, ? Edwards, Alfred Summers, George Mock, and ? Welge. Below is the installation dinner. (Both, Village of South Floral Park.)

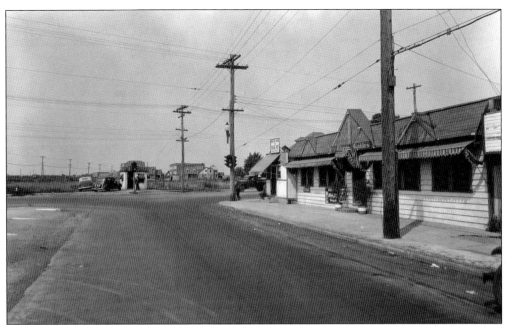

Stop 20 on the Hempstead Turnpike trolley line was at the intersection of Hempstead Turnpike and Covert Avenue. By the time these 1937 photographs were taken, the trolley lines had been gone for 11 years. The above photograph shows automobiles turning north down Covert Avenue. In the background is the Covert Avenue School (built in 1925 for the influx of residents on the East End of Elmont) and, beyond that, Sewanhaka High School in Floral Park. In the foreground are Meacham Avenue and the Three Gables Diner/Tavern. The below photograph shows the opposite angle, with the Three Gables Diner on the southeast corner of Meacham Avenue and Hempstead Turnpike. It later became the site of King Umbertos. To the left is a grocery store next to Barney's Hardware. (Both, Nassau County Police Museum.)

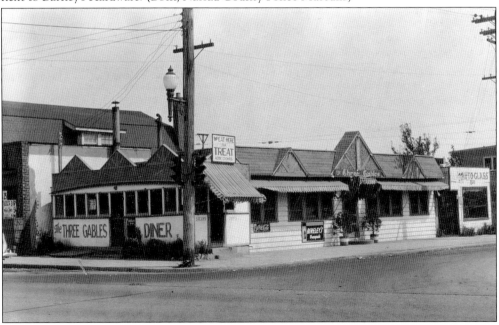

These 1946 photographs show the construction of the Tudor Plaza Building and the Tudor Manor neighborhood at the corner of Elmont Road and Central Avenue/Linden Boulevard (the Tudor Plaza would open in 1947). The northeast corner was previously the farm of Reinhardt Robrecht. The below photograph shows the intersection in a view looking south from Elmont Road. In the distance is Herman's Bar and Grill, and to the right is the Hoffman Farm. At far left, behind the Tudor Building, is Van's Nursery, opened in 1944 by Louis and Lillian Van Deinse. (Both, Nassau County Police Museum.)

This 1940 photograph shows the intersection of 241st Street and Kaplan Avenue (today's Alden Avenue) in Alden Terrace. A short-lived street, 241st Street was divided from Fosters Meadow Road and was later combined back into it after Laurelton Parkway was complete. In the background are the stores at Oliver Avenue. To the right is the parkway. To the left is the former property of the Rottkamp family. (Nassau County Police Museum.)

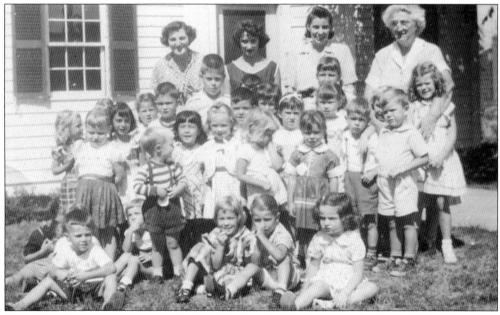

The Alden Terrace area was mostly developed on the Finn property in North Valley Stream on Central Avenue. The developers were Phoebus Kaplan and Jesse Hartman. In the 1940s, the Alden Terrace School was built on Central Avenue to accommodate the increased population. This 1953 photograph shows the kindergarten class at the Alden Terrace Baptist Church. (Author's collection.)

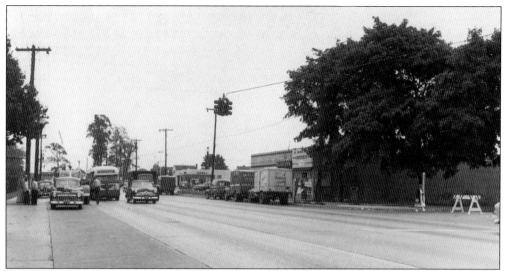

Locustwood Estates was developed by E.A. White on land owned by Belmont Park. Houses first went on sale on August 13, 1927. On May 17, 1946, GI Homes were built in Locustwood Estates on Huntley Road, Wellington Road, Heathcote Road, Locustwood Boulevard, Sussex Road, Sterling Road, Warwick Road, Essex Road, Fieldmere Street, and Hathaway Avenue. This photograph is from 1948. (Nassau County Police Museum.)

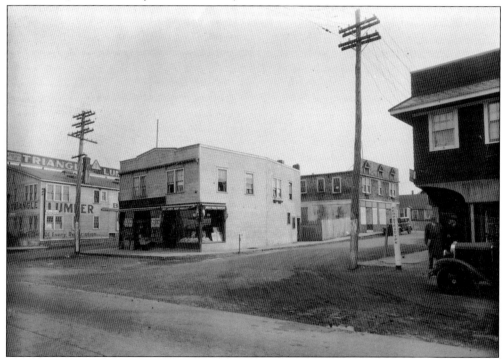

The Gotham area was developed in the 1920s by Elzey Meacham. Most of the streets were named after hotels. In the 1940s, Gotham Avenue School was built for the community. In 1989, the Locustwood Civic merged with the Gotham Civic to represent the area south of Hempstead Turnpike and west of Elmont Road north of the Parkhurst section. This photograph shows the intersection of Savoy Avenue and Hempstead Turnpike. (Nassau County Police Museum.)

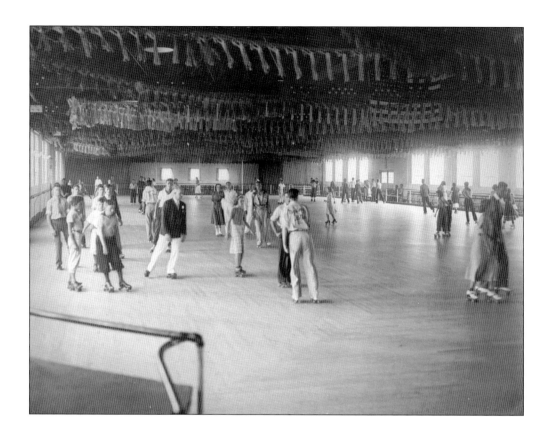

Wal-Cliffe skating rink and pool was opened in 1931 by Bert Hinchcliffe and a Mr. Waldren. They got the name Wal-Cliffe from a combination of their names. In the 1930s, they held sweepstakes and number parties to attract skaters. Hal Kearns was the musician in residence, playing his Hammond organ as teenagers skated. In the below photograph, note Wal-Cliffe's lounge area and its iconic hexagonal benches. (Both, Nassau County Photograph Archive.)

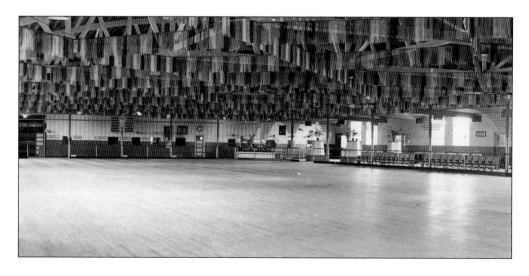

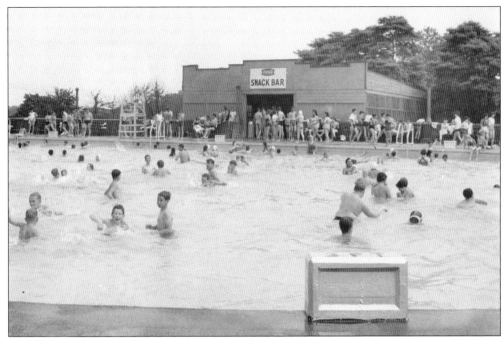

Wal-Cliffe's swimming pool (marketed as the only elevated swimming pool on Long Island) used New York City drinking water thoroughly filtered and sterilized on-site. When the pool opened, it held 500,000 gallons of water and measured 167 feet by 200 feet. Surrounding the pool, as noted in advertisements, were a sand beach, refreshment stand, handball courts, a waterslide, high and low diving boards, a miniature golf course, and other sporting activities. Wal-Cliffe marketed itself as a sanitary alternative to the beach, which may have been comforting since it abutted Beth David Cemetery. Its "hidden" location at the intersection of Belmont Boulevard and Johnson Avenue (near Clara H. Carlson School) was also appealing. (Both, Nassau County Photograph Archive.)

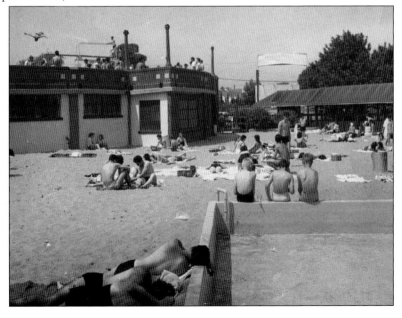

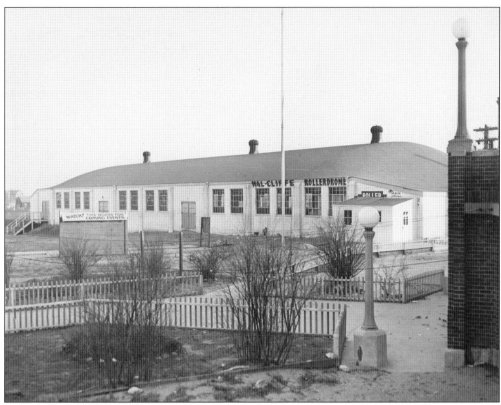

Wal-Cliffe RollerDrome and Swimming Pool lasted until the late 1980s. In 1933, it was expanded for the first time. In 1959, Wal-Cliffe caught fire for the first time; it reopened in 1960. Wal-Cliffe eventually changed its name to the Roller Castle and finally shut down after a fire on January 16, 1988. The property is now used for housing. Wal-Cliffe claimed the name of its neighborhood was Queens Park Gardens or Vandermere Villa (most advertisements for the Elmont landmark did not list Elmont as its location, sometimes claiming it was "near Franklin Square" or "close to the City."). Belmont Boulevard, the main thoroughfare to Wal-Cliffe, has changed from a major roadway to a quiet residential one. (Both, Nassau County Photograph Archive.)

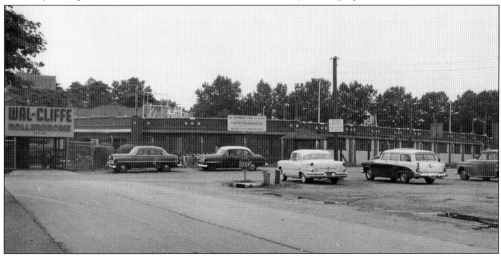

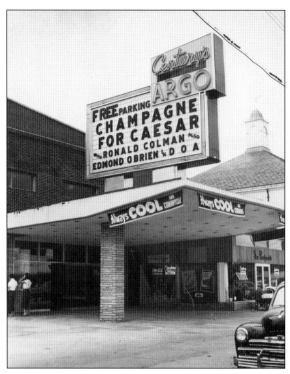

The one-screen Argo Theatre opened on the southwest corner of Hempstead Turnpike and Elmont Road in 1950. It was originally run by Century but later became an independent theater before closing and becoming a club and a store. The marquee, made by the Serota Sign Corporation, is no longer standing, but the building is still an integral part of Elmont's commercial district. In the background of this photograph is the cupola of the Franklin National Bank. (Serota Sign Corp, photograph by Ralph Tornberg.)

Franklin National Bank's original headquarters are in Franklin Square. It was founded as Franklin Square National Bank in 1926. After changing its name to Franklin National Bank in 1947, it expanded to other locations in Long Island and New York City, including the iconic building in Elmont next to the Argo Theatre on Hempstead Turnpike. Franklin National Bank collapsed financially in 1974 in one of the largest bank failures in history. The Elmont building still stands, and most recently housed a club. (Author's collection.)

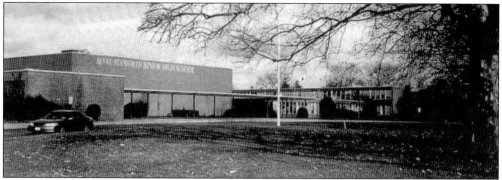

Alva T. Stanforth (ATS) Junior High School opened on September 10, 1956, with 1,055 students and 45 teachers. It was named after Dr. Alva T. Stanforth, one of the first principals of Sewanhaka High School (he retired in 1947). Alton D. Lowe was the first principal of ATS Junior High. The school shut down in 1983 due to declining enrollment. After years of being vacant, the building was torn down, and the Elmont Memorial Library opened at that location in 2006. (Elmont Memorial Library.)

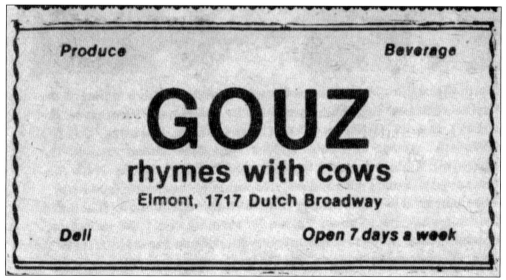

Gouz Dairy is an Elmont landmark known for its unforgettable slogan: "Gouz Rhymes with Cows." Many have memories of the milk and the animals the Gouz family kept on the property. Gouz suffered a fire in 1977, and soon after, the family moved to Florida and closed the dairy. A Western Beef now sits in the Gouz building, and a Dollar Store sits in the Daitch Supermarket space next door. This advertisement is from the 1950s. (Village of South Floral Park.)

In the mid-1950s, the Rottkamp family sold 20 acres of their farm to John L.A. Bond, a lawyer from Massapequa who planned to build a shopping center on the property (the Town of Hempstead wanted to build a park). This 1967 photograph shows the main store on the property, Great Eastern. It later became a Times Square Store, and in 1990, Home Depot. Other businesses on the property have included Sizzler, OfficeMax, Coconuts, and Pep Boys. (Elmont Memorial Library.)

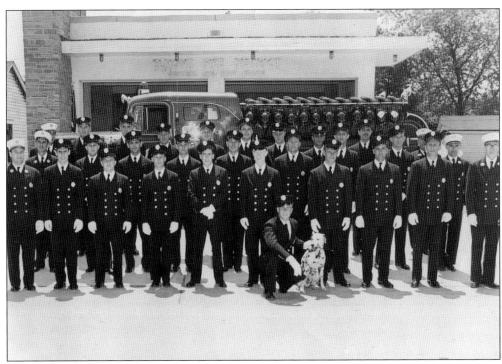

Elmont Engine Company No. 4 formed in 1952 to protect the southern parts of the Elmont Fire District, including Alden Terrace and North Valley Stream. The newly formed company poses for this group photograph on Memorial Day in 1952. (Elmont Fire Department Historical Society.)

The town of Hempstead had a number of council members from the Elmont area. Ernest Steinbrenner (pictured), who sat on the town council from 1941 to 1960, was also the leader of the Elmont Republican Club. Harold Paul Herman, son of John M. Herman, was the town's supervisor and presiding supervisor from 1938 to 1955, as well as a councilman and assemblyman. Joseph Muscarella, patriarch of his politically prolific family, was also from Elmont during his town board tenure. (Nick Famiglietti.)

This advertisement from the late 1950s is for Foods of All Nations. The building later housed the neighborhood landmark Sapienza Bakery. In place of the clock that sits atop Sapienza today, Foods of All Nations had a globe as its symbol. The business was later turned into a Peter Pan Bakery. (Nick Famiglietti.)

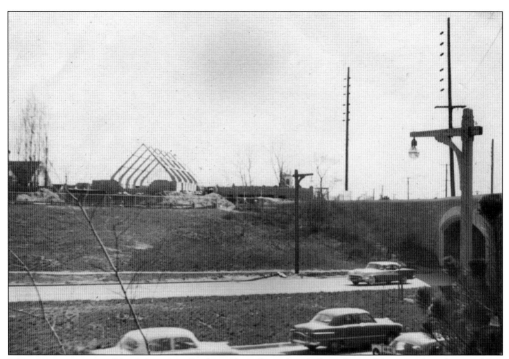

The congregation of St. John's Methodist Church realized that their old 1840 church in Alden Terrace in North Valley Stream was too small, so they constructed a new church building on the corner of Elmont Road and Stuart Avenue and opened it in 1956. The above photograph shows the construction of the new church as seen from the Southern State Parkway. The below photograph shows the church removing the bell from the old building in preparation for its installation in the new one. Later in 1956, the cupola was removed. The old 1840 church still stands as the Parish Resource Center. In 1968, the church changed its name to St. John's United Methodist Church of Elmont. The makeup of its congregation has shifted from primarily white to 99 percent black. (Both, St. John's Methodist Church.)

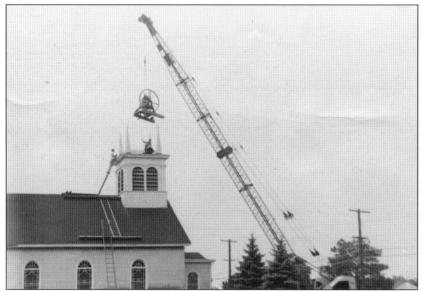

The Belmont Park Inn sat at 35 Plainfield Avenue, just north of Hempstead Turnpike, and across the street from Belmont Park. Behind it was the neighborhood of Jamaica Square. John Tierney was the owner when this photograph was taken in 1952. The 1927 building still stands and is now the Parkway Motor Inn. (Author's collection.)

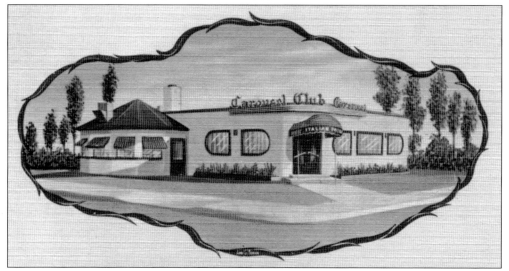

Club Carousel, operated by Frank and Carmela Nocella, sat on the corner of Heathcote Road across the street from Belmont Park from 1946 to 1959. The club was known for its Italian food and shows that attracted people in the days before television. Acts like Jerry Vale, the Isley Brothers, and Nipsey Russell were regulars. The building still sits at 127 Hempstead Turnpike. (Author's collection.)

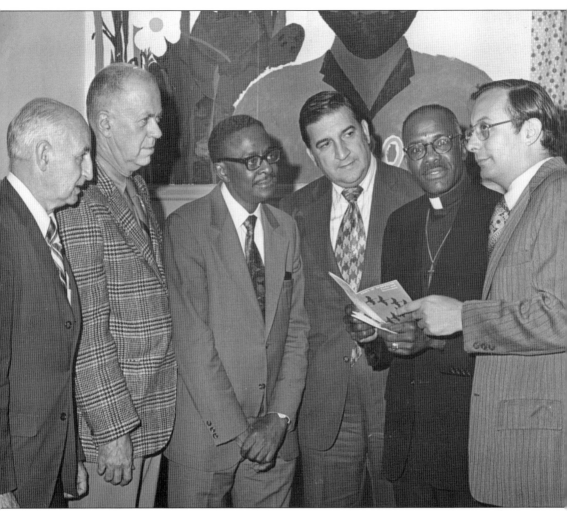

Rev. H. David Parker came to Jamaica Square in 1963, becoming pastor of Emanuel Baptist Church. Parker made it his mission to better the people of Elmont, forming the Jamaica Square Improvement League in 1964 and the National Council of Black Clergy in 1972. He served on Nassau County's Human Rights Commission for 16 years and was part of the Interracial Task Force. Parker retired in 2008 and passed away in 2015, but part of Hendrickson Avenue in front of the church has been named after him. The Jamaica Square Improvement League has become one of the most influential civic groups in Elmont under leaders George Anderson, Mary McRae, William Garnett, and Claudine Hall. Pictured here are, from left to right, ?, George Endres, Anderson, Councilman Joseph Muscarella, Parker, and Town Supervisor Alfonse D'Amato. (Vincent Muscarella.)

Emanuel Baptist Church in Jamaica Square was organized in 1928 at a home on Plainfield Avenue. In 1962, Rev. Larry W. Ellis dedicated a larger church in Jamaica Square. Rev. H. David Parker became pastor in 1963 and, before he retired in 2008, helped to grow the congregation from 60 people to over 600. The church is still a central part of Jamaica Square. (Author's collection.)

St. Vincent de Paul Roman Catholic Church started in 1951 in the "dugout" of American Legion Post 1033. The church was dedicated in 1953 on land donated by the Rottkamp family. In July 2016, due to a shrinking congregation, the parish sold the church and rectory to a Syro-Malankara Eastern Catholic church (the congregation mainly consists of Indian immigrants). It is now a cathedral for the Syro-Malankara Catholic Eparchy of the United States and Canada. (Author's collection.)

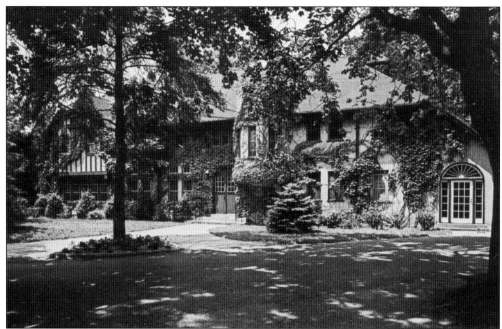

The Wayside Home School for Girls was started in Brooklyn in 1880 to help women released from prison. In 1917, it moved to 14 acres off Dutch Broadway in North Valley Stream with a new mission: helping troubled girls under 18. The Salvation Army took over the campus in 1935. Wayside Home shut down in 2003. The Dutchgate Townhouses are now located on its former site. (Christina Scali.)

Charles and Harriet Murphy owned a fish store in Elmont for decades. In 1983, they purchased a 15-foot-tall fisherman statue and placed it outside the store. The statue became a local landmark, even after Charles died and Harriet closed the store in the 1990s. After it was subject to numerous attempts at vandalism, the Murphy family donated the statue to the Town of Hempstead Beach; it still stands at the entrance to Point Lookout. (Author's collection.)

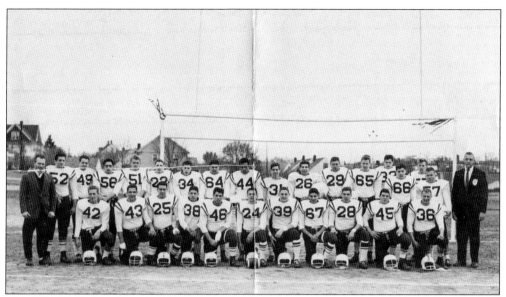

The above photograph shows the 1962–1963 Elmont High School football team, which had a 6–2 record. From left to right are (first row) John Stefare (42), Michael Molano (43), Thomas Allen (25), Mark Kaufman (38), Steven Montagino (46), Gary Hoffman (24), Saul Sindell (39), Charles Russo (67), Ken Del Vecchio (28), Fred Vecchione (45), and Warren Smits (36); (second row) Paul Friedman (52), Neil Silven (49), Arthur Menangie (56), Mickey Keough (51), Marc Schumacker (22), James Boccia (34), Bruce Shanon (64), Al Lalli (44), David Fischler (31), Peter Cuti (26), Jackie Lorenge (29), Stanley Johnson (65), Joel Rubin (32), Erwin Meslin (66), Tim Fleischman, and Thomas Daniels (57). The coaches' names are not known. Below are the Elmont Midget Cardinals in the 1960s. At center is Hempstead Town councilman Joseph Muscarella Sr. (Above, Arlene Schack; below, Vincent Muscarella.)

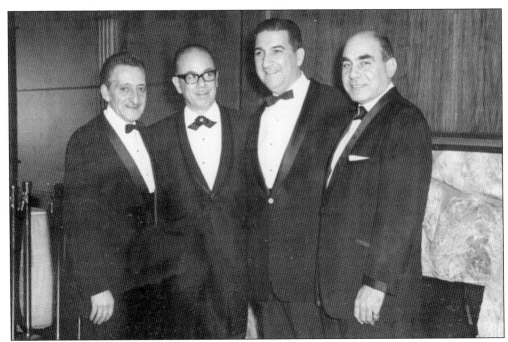

Until recently, Elmont was a Republican stronghold. One exception was Al Semenga, a Democratic acting supreme court justice from Elmont. He later became county attorney under Republican Thomas Gulotta from 2000 to 2001. Pictured above are, from left to right, unidentified, Al Semenga, Republican town councilman Joseph Muscarella from Elmont, and Republican judge Barney Thomas Pantano. The below photograph shows the Elmont Republican Club in the 1960s. From left to right are: (first row) Ralph Yachnin, Harry Yoss, Margret Beshears, Joseph Muscarella, Hempstead supervisor Francis Purcell, executive leader Joseph Williams, Christian Becker, and John Reinhardt Sr; (second row) three unidentified, Nicholas LaGinestra, two unidentified, Anthony "Tippy" Nocella, unidentified, Peter Lanciotti, Joseph Carlino Sr,, and Joseph Carlino Jr.; (third row) Frank Gallo, Daniel Ryhkar, John Wohltmann, James Marsh, Andrew Ortolano, Clyde Collins, Andrew Russac, Reginald Snyder, and two unidentified; (fourth row) Alexander Hillmeyer, Joseph Zimny, Assemblyman Anthony Barbiero, unidentified, Michael Starito, Thomas Ehly, Frank D'Agostino, John Catazaro, Anthony DeCicco, Charles Dellasandro, and John Orlando. (Both, Vincent Muscarella.)

William "Bill" Rottkamp, grandson of Henry Rottkamp of Elmont, opened a beer and soda distributorship at 741 Elmont Road. The company was dissolved in 2002, and Rottkamp died in May 2015 at age 85. Rottkamp was active in Franklin Square, including in the Knights of Columbus, St. Catherine of Sienna Church, and the Franklin Square Historical Society. Pictured in the below photograph at the Franklin Square Historical Society are, from left to right, county legislator Vincent Muscarella, county legislator John Ciotti, Rottkamp, Elizabeth McIsaac (vice president of Franklin Square Historical Society), Franklin Square historian and Franklin Square Historical Society president Dr. Paul Van Wie, and Hempstead Town councilman Edward Ambrosino. (Above, Nick Famiglietti; below, Vincent Muscarella.)

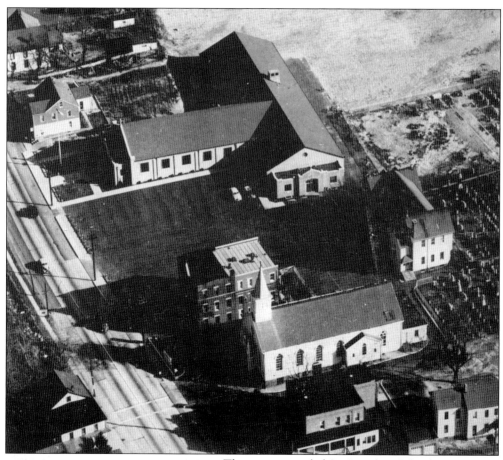

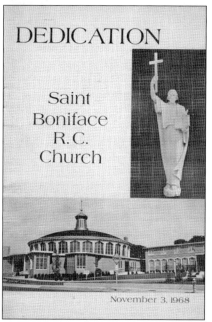

DEDICATION

Saint
Boniface
R.C.
Church

November 3, 1968

The new, expanded St. Boniface School was dedicated in 1951 and was part of Fr. Joseph Hack's plan to replace the church's old 19th-century structures. He replaced the convent in the 1950s and the rectory in 1968. A new church, based on a space-age design from the Vatican Pavilion Chapel at the 1964 World's Fair, replaced the old church building in 1968. The school closed in 2004, but all the buildings still stand today. St. Boniface has reached out to the Haitian and Hispanic immigrant communities in Elmont by holding masses in Spanish and Haitian Creole. The above photograph was taken after the new school was dedicated but before the new church was built. At left is the dedication booklet for the new church featuring a picture of the innovative design. (Above, Elmont Memorial Library; left, author's collection.)

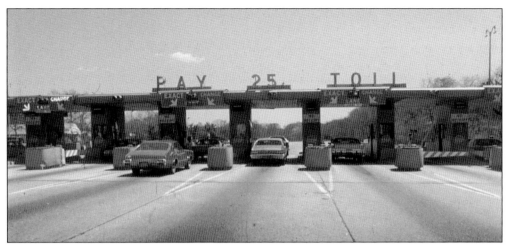

Construction of the Southern State Parkway began in 1925 on land Robert Moses took from the Brooklyn Water Works. The original section of the parkway, from North Valley Stream to Hempstead, opened in 1927. Starting in 1948, a concrete barrier was constructed to separate the four-lane roadway by direction, and in 1954, completely new roadways and arches were constructed for opposite direction traffic. The tollbooth shown here was between exits 13 (Central Avenue) and 14 (Fletcher Avenue) in North Valley Stream. The toll was originally 10¢, but it was bumped up to 25¢ in the 1970s. The toll was removed in 1978, and the booths soon after. The tunnel beneath the booths (used for staff changes) is still there. (NYS DOT.)

Here, a remnant of the original infrastructure is visible from the overpass; it is a staircase at exit 15 (North Corona Avenue), which pedestrians could take to get to Valley Stream State Park from north of the roadway. Now, it connects to nowhere and sits in the median. (Author's collection.)

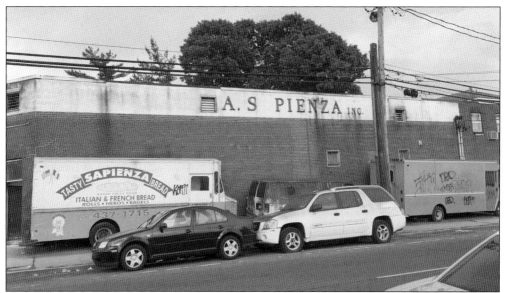

Andrew Sapienza built his bread factory on Meacham Avenue in 1948 and doubled its size in 1955. This was a wholesale bakery and only sold to stores and restaurants. A fleet of trucks delivered to other establishments. Sapienza sold the bakery in 1976, but the building still bears his name. (Author's collection.)

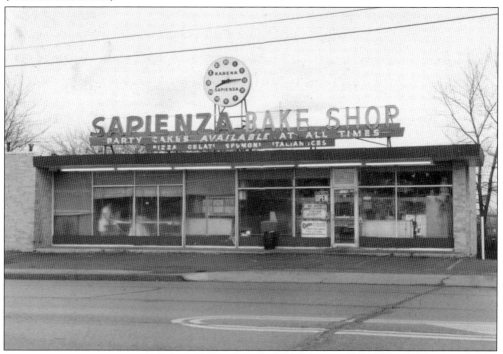

Andrew and Angelina Sapienza bought this storefront bakery on Hempstead Avenue in 1967 and changed its name from the Peter Pan Bakery to Vesuvio's. The building was erected in 1959 as a Foods of All Nations, and its famous clock was originally a globe. (The globe became a clock when it was the Peter Pan Bakery.) Andrew's son Paul took over the business in 1973 and changed the name to Sapienza. (Paul Sapienza.)

Congressman Jack Wydler is pictured here in 1962 rallying the Elmont Republicans of Sussex Road for his first election to Congress. Elmont was a Republican stronghold until new immigrants from the Caribbean and Central America arrived and shifted the base in the area. In 2012, longtime North Valley Stream Republican county legislator John Ciotti lost his election to Carrie Solages, an Elmont Democrat and son of a Haitian immigrant. Ciotti passed away in January 2017. (Lorraine Pennoro.)

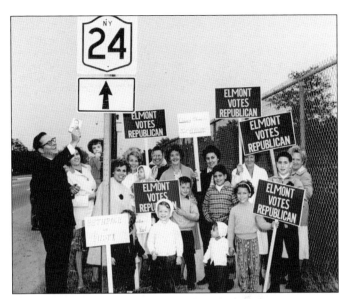

In 1975, a referendum failed to change the Nassau Board of Supervisors to a legislature. Cecelia Muscarella, the widow of Councilman Joseph Muscarella Sr., ran as a candidate to represent Elmont and Franklin Square. From left to right in this campaign photograph of Cecelia and her children are Joseph Jr., Beatrice, Thomas, Cecelia, Michael, and Paul. Absent from this photograph are Cecelia and Joseph Sr.'s sons Ignatius and Vincent. (Vincent Muscarella.)

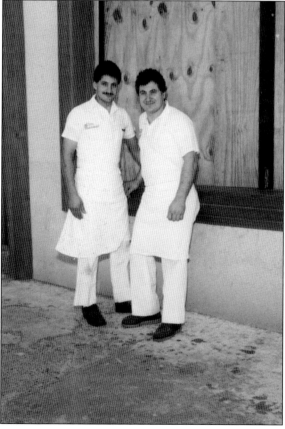

King Umberto Pizzeria was opened in 1976 by Joe Corteo, brother of the owners of Umberto's of New Hyde Park, on the southeast corner of Meacham Avenue and Hempstead Turnpike. Corteo sold it to brothers Rosario (left) and Sal Fuschetto (pictured at left), two employees under Corteo, who hired Ciro Cesarano and Angelo Giangrande. It was here that a unique Long Island–style pizza, the Grandma's Pizza, was invented (it was originally conceived in Umberto's but first went on the menu at the insistence of Cesarano and Giangrande at King Umberto). Elmont resident Anthony "Tippy" Nocella is credited with giving the pizza its name. Since King Umberto started selling Grandma's Pizzas, most pizzerias in Nassau, Suffolk, and even Queens County also sell a version. It is virtually unheard of west of Brooklyn. Also of note: in the above photograph, Barney's Hardware, a longtime Elmont business, is on the far left. (Both, Ciro Cesarano.)

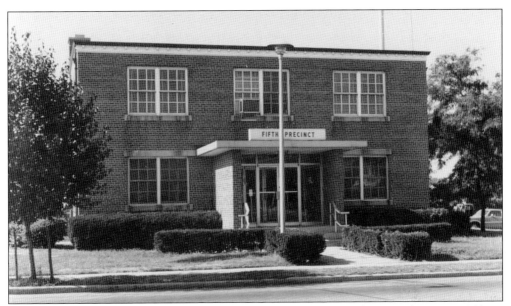

The Fifth Precinct moved from Valley Stream to 1655 Dutch Broadway in Elmont in 1963—a property that was formerly Jake Roper's Dog Pound. (They uncovered animal bones during excavation.) The precinct had previously been located at 30 West Jamaica Avenue in Valley Stream from 1930 to 1963, and 272 Merrick Road in Valley Stream in 1929. The Valley Stream Police Department merged into the Nassau Police in 1929. (Nassau County Police Museum.)

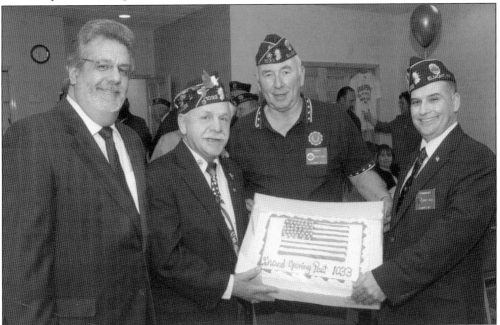

The Elmont American Legion Post 1033 went through remodeling in 2010. This photograph is from its grand reopening. From left to right are county legislator for the Third District, John Ciotti, of North Valley Stream; Nassau County Veterans Service director and Elmont resident Ralph Esposito; Gene Van Harren; and post commander Steven McManus. (American Legion Post 1033, Elmont.)

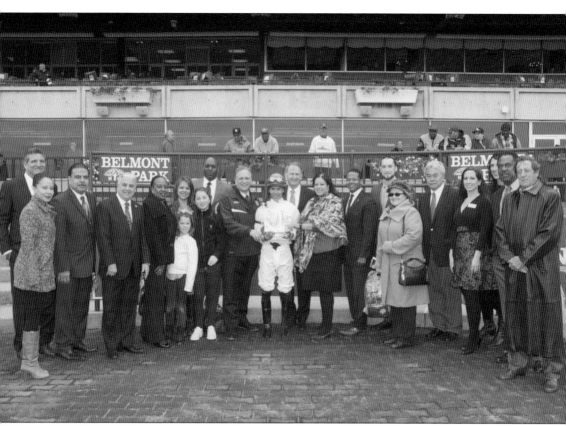

This 2016 photograph of Belmont Park on opening day shows the growing change in the area. Congratulating winning jockey Jose Ortiz (center) are Nassau County executive Edward Mangano, Nassau County legislator Carrie Solages (of Elmont), New York state assemblywoman Michaelle Solages (of Elmont), mayor of the village of South Floral Park Geoffrey Prime, South Floral Park trustee Elton McCabe, mayor of the village of Floral Park Thomas Tweedy, Floral Park trustee Archie Cheng, president of the South Floral Park Civic Association Anthony Barbieri, South Floral Park civic secretary Marian Kelly, president of the Long Island Hispanic Chamber of Commerce Luis Vazquez, chair of the Elmont Coalition for Sustainable Development Sandra Smith, and Nassau County sheriff Michael Sposato. (Nassau County.)

Three

ROSEDALE

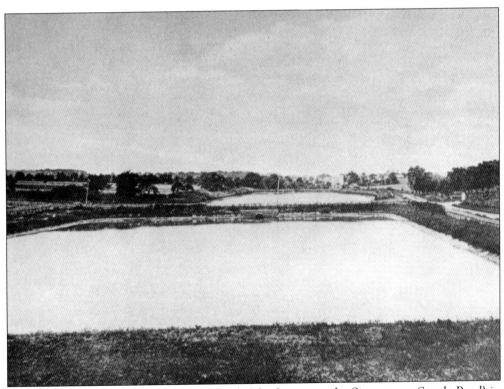

This 1896 photograph shows the Twin Ponds (also known as the Simmonson Supply Pond) in Rosedale. Merrick Boulevard runs through the middle of the ponds, while Fosters Meadow Road runs south on the right side. The Albert Schmitt farm is on the left. In 1933, the Twin Ponds were drained for construction of the Interborough Parkway's Laurelton Parkway. (Queens Borough Public Library Archives, Illustrations Collection–Laurelton.)

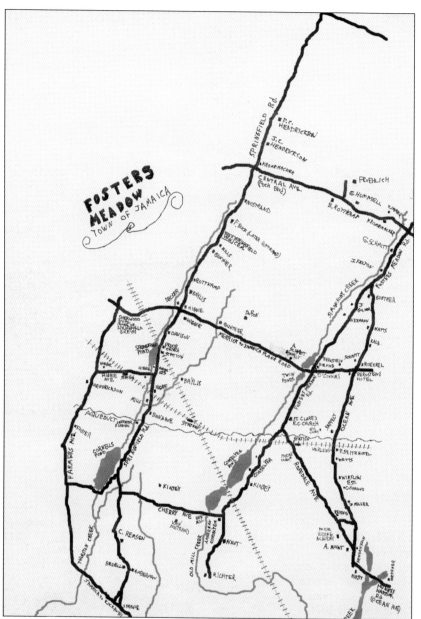

The western half of Fosters Meadow was in the town of Jamaica and consisted of Rosedale, Laurelton, Brookville, Springfield Gardens, and Cambria Heights. Parts of Queens Village and St. Albans were influenced by the development of Fosters Meadow. This map shows the names of families who occupied land in Fosters Meadow from about 1850 to 1930, as well as the original names for area roads. Central Avenue/Foch Boulevard is now Linden Boulevard. Springfield Road is now Springfield Boulevard. Fosters Meadow Road is now Brookville Boulevard (and part of Elmont Road). Ocean Avenue is now Hook Creek Boulevard, and the other Ocean Avenue and Hungry Harbor Road is now Rosedale Road. Rosedale Avenue is now Francis Lewis Boulevard. Cherry Avenue is now 147th Avenue. Higbie Avenue is now 140th Avenue. Merrick to Jamaica Plank Road is now Merrick Boulevard, and Jamaica-to-Rockaway Turnpike is now Rockaway Boulevard. (Author's collection.)

74

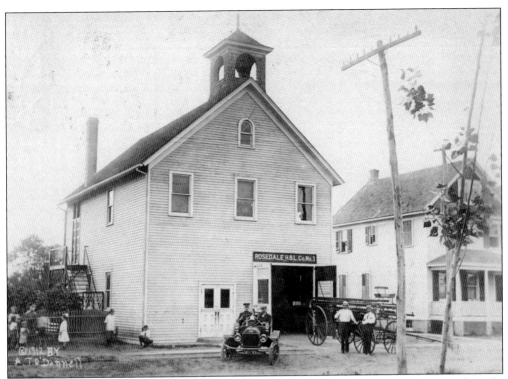

Rosedale Hook & Ladder Company No. 1 was organized in October 1904 with 15 members. In 1907, a fire hall was erected on Fosters Meadow Road to house their equipment. The company was disbanded in December 1927. Rosedale Chemical Engine Company was organized in 1909. It, too, was disbanded in 1927. (Nassau County Photograph Archive.)

The South Side Rail Road first stopped in Rosedale at Hook Creek Boulevard in May 1870. A station house—Fosters Meadow Station—was built between June and July 1871. The name was later changed to Brookfield Station. It closed in 1889 and was used as a shed while a new station was built. In 1892, the station changed its name to Rosedale. Note the advertisement for Orson Welles's *Native Son*, which was on Broadway in 1942. (Queens Borough Public Library, Archives, Ron Ziel Collection.)

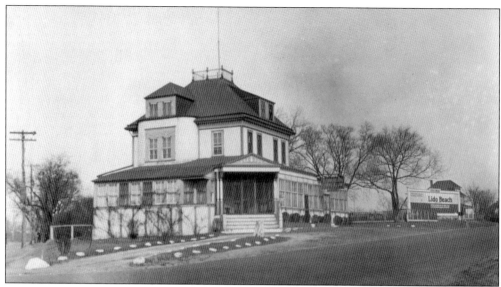

O'Connor's Inn and Hotel, located at the northeast corner of Brookville Boulevard and the Twin Ponds, was a well-known roadhouse on Merrick Road. O'Connor's opened before the 1880s and closed in 1964. Note the sign for Lido Beach at far right in this photograph from March 9, 1927. (Queens Borough Public Library, Archives, Eugene Armbruster Photographs.)

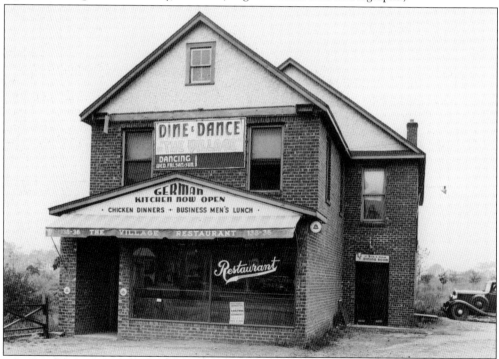

This September 29, 1938, photograph of the Village Restaurant in Rosedale has a sign for Carlton Beer in the window; they could finally sell it again after Prohibition (another sign promotes baseball at Sherwood Oval, where the Springfield semiprofessional team played). The Village Restaurant was located at 138–36 Brookville Boulevard and was later McCabes Bar. The building no longer exists. (Queens Borough Public Library, Archives, Frederick Weber Photographs.)

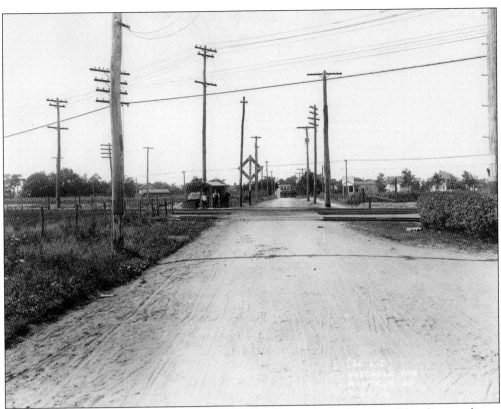

The above photograph shows Rosedale Avenue (now Francis Lewis Boulevard) heading northwest towards Fosters Meadow Road (Brookville Boulevard) and crossing over the Conduit and the railroad tracks in July 1910. This part of Rosedale was not developed beyond farms at this point, and Rosedale Avenue did not go past Brookville Boulevard. The below photograph shows the Long Island Traction Company trolley lines approaching Hook Creek Boulevard in 1910. The trolley ran all the way to Freeport, then went north to Hempstead and split off to Jamaica and Mineola. (Above, Queens Borough Public Library, Archives, Public Service Commission Photographs; below, Queens Borough Public Library, Archives, Illustrations Collection–Rosedale.)

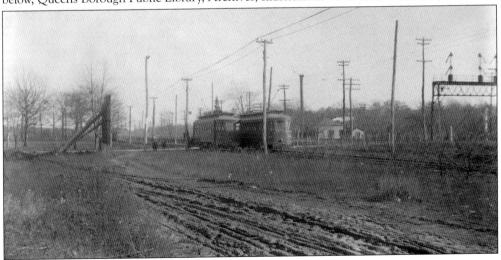

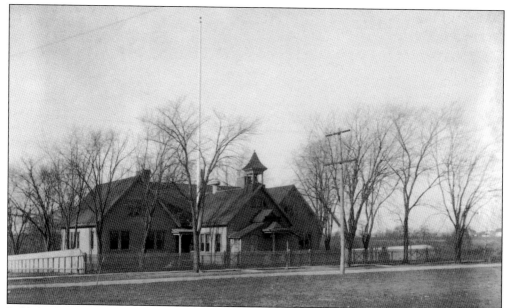

Public School 38 Queens (PS 38Q), shown in this 1915 photograph, was located on the west side of Fosters Meadow Road. PS 38Q eventually moved around the corner to 241st Street. This old building still stands (minus the front and cupola). In 1935, it was moved to 135th Avenue during Laurelton Parkway construction and raised on a new foundation. The building now houses the Rosedale-Laurelton American Legion Post 483. (Queens Borough Public Library, Archives, Illustrations Collection–Rosedale, Eugene Nichols Photographs.)

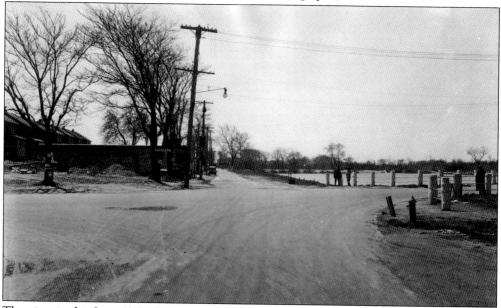

The view in this June 1927 photograph looks south down Brookville Boulevard from Merrick Boulevard at the Twin Ponds (from the vantage point of O'Connor's Inn.) Beyond the right side of this photograph would be the farm of Albert Schmitt. Behind the photographer would be the Boening property. The Twin Ponds were drained for construction of the Interborough (Laurelton) Parkway in 1933. (Queens Borough Public Library, Archives, Frederick Weber Photographs.)

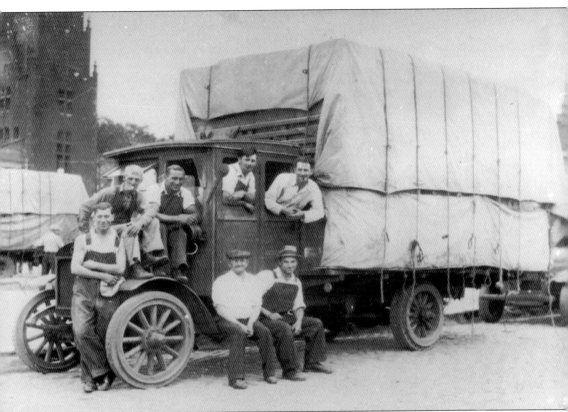

Henry Schmitt and his wife, Ernestine (daughter of Herman Sappelt), moved onto 21 acres at Merrick Boulevard at the Twin Ponds in 1888. Henry died in 1903, and his son Albert (born in 1863; married Margaretta Kappelmeier) took over the farm. Albert's siblings included Ferdinand (born in 1861); Clara (born in 1867; married Anton Rottkamp, son of Bernard Rottkamp); and Emma Ottilie (born in 1869; married Philip Hoeffner). Albert farmed the land until he died in 1941. His five sons sold it in 1946 and started other farms: Philip and Tony went to Farmingdale; Albert went to Melville; Fred went to Carman Avenue in Westbury; George (married Theresa Rottkamp, daughter of Joseph Rottkamp of Springfield Road) went north to the border of Elmont and Cambria Heights. He ran a 14-acre farm until it was taken via eminent domain for the Laurelton Parkway. His son Ambrose ran a farm on Hook Creek Boulevard. This 1931 photograph shows the Schmitts selling goods at Wallabout Market in Brooklyn. (Albert Schmitt.)

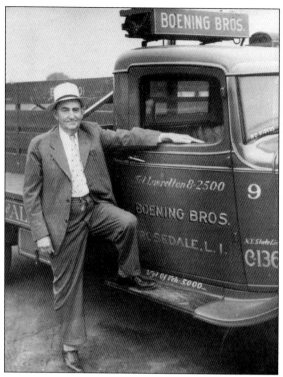

In 1901, Phil Boening Sr. went into the wholesale beer distributor business. As a farmer in Rosedale, he made trips to the breweries in Bushwick for spelt grain. Before every trip, neighbors asked him to bring back beer. Boening realized that it was more profitable to ditch the whole farming business and just distribute beer. Eventually, his sons Phil Jr. (pictured) and Harry took over the business. During Prohibition, they sold Near Beer and soft drinks and are credited as the first to bring Pepsi and 7Up to Long Island. In 1966, they sold the Rosedale property and moved to Lindenhurst. The 1936 photograph below shows the Boening Brothers truck fleet at 133–11 Brookville Avenue. In the background, beyond the newly constructed Laurelton Parkway and Twin Ponds, is the Albert Schmitt farm. Harry Boening married Margaret Schmitt in 1926. His son, Hap Boening, currently runs the company. (Both, Hap Boening.)

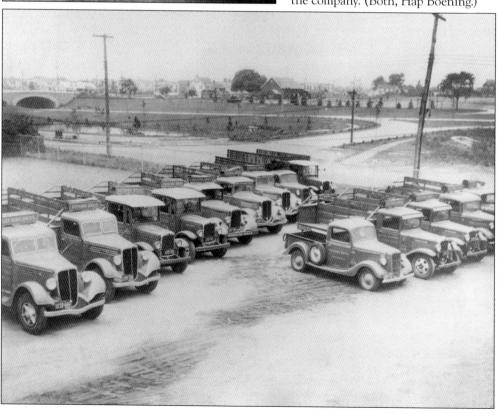

Joseph S. Roeckel came to America from Bavaria in 1845. He opened his general store on the corner of Ocean Avenue (Hook Creek Boulevard) and Merrick Road in 1858, where he served as postmaster. His son George bought the store in 1887, expanding it a few years later and also becoming postmaster. This 1900 receipt from George Roeckel's store shows the many purchases made by a Mr. Hardy. (Author's collection.)

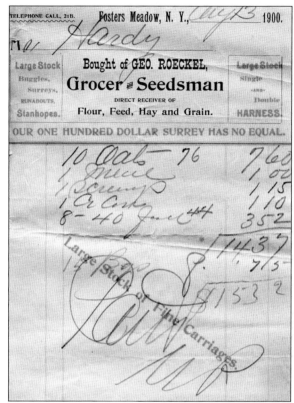

In 1910, the Roeckel general store was replaced by Hen Karkick and Bill Jackson's garage (later owned by Moses Rodnensky and Jack Studnick). Across Merrick Road was the Henry Rosenkranz Hotel. Diagonally across the road was the Bernstein Hotel (later replaced by the Rosedale Lanes). Across Ocean Avenue (Hook Creek Boulevard) is J&S Pizza, and just north of that, Ambrose Schmitt's Farm. (Valley Stream Historical Society.)

The Evangelical Lutheran Church of Christ congregation was founded in January 1913. In January 1916, a church building was constructed on Rosedale Road (Francis Lewis Boulevard). Many alterations started in 1950, and a new bell tower was dedicated in 1968. In 1955, the church lent its basement to a growing Jewish congregation. (Author's collection.)

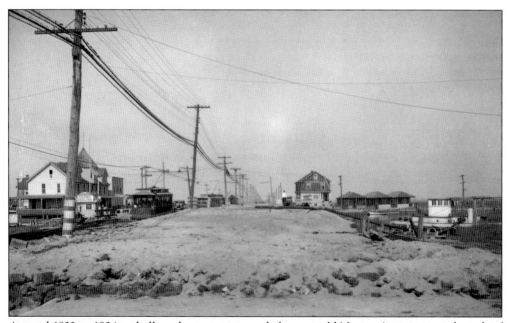

Around 1833 or 1834, a shell road was constructed along an old Native American trail south of the salt marshes. This toll route, known as the Rockaway Road and the Jamaica-to-Rockaway Turnpike, became a stagecoach route and later a trolley line. This 1915 photograph shows Rockaway Road (now Boulevard) running by the Meadowmere community where it meets "Snake Road" (now Brookville Boulevard). (Author's collection.)

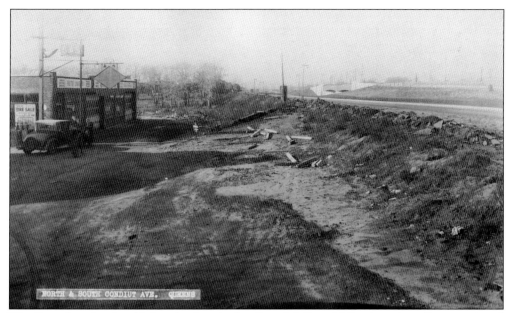

The Conselyea family sold their land to Arthur Beaudel. Beaudel Brothers Auto Repairs opened on South Conduit Avenue in the early 20th century. When New York City decided to develop the land around Conselyea Pond as Brookville Park, it condemned the Beaudel property. In this December 1937 image, the land around the repair shop is being excavated to create Brookville Park. (Queens Borough Public Library, Archives, Public Service Commission Photographs.)

On the southwest corner of Brookville Boulevard and 147th Avenue was the Amberman/Conselyea Grist Mill. Here, in front of the mill, Major Richard Stockton executed Derrick Amberman in 1781. In the 1950s, boxer Rudy Felix opened Pizza King in this building. The Sons of Italy occupied it after Pizza King, and it currently houses the Rosedale Medical Center. (Author's collection.)

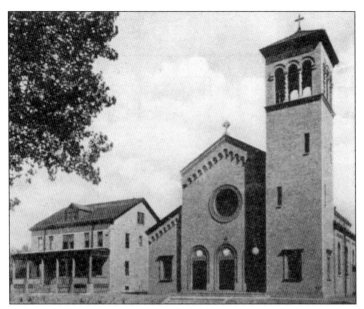

Due to the increased Roman Catholic population in the Rosedale area, Bishop Thomas Molloy established St. Clare's Parish in 1924. This 1927 photograph shows the church and rectory on Brookville Boulevard. The congregation met at St. Boniface and then the Rosedale Volunteer Fire Department before the church was built. Rosedale residents and actors John Turturro and Barbara Bach were congregants here. (Diocese of Brooklyn.)

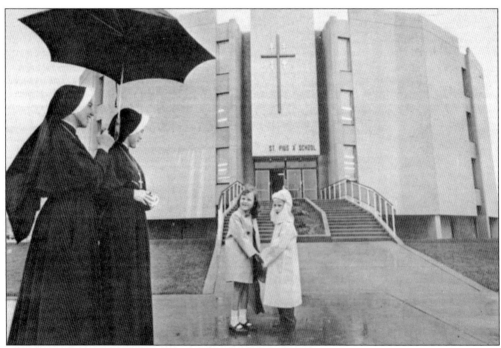

The large number of Roman Catholics in Rosedale led to the creation of another area parish in 1960. St. Pius X Church was dedicated in 1962 and served many in southern Rosedale. In 1965, St. Pius X opened the school shown in this photograph. It was completely soundproof, so the planes flying overhead from John F. Kennedy International Airport would not be heard. The school is now closed, but the building still stands. (Diocese of Brooklyn.)

Ted Kohler is noted in this gathering of the Rosedale Luther League at Coney Island in the 1920s. The Luther League was the youth group from the Evangelical Lutheran Church of Christ. Also in this picture are George Krase, Alina Young, Ray Lederle, Albert Damp and ? Oldacker. The Kohler family lived on 136th Road in Rosedale. (Jean Kohler.)

Whitey's Riding Academy had two locations in Rosedale, one on the former Mount property at the intersection of Hook Creek Boulevard and Francis Lewis Boulevard and the other slightly farther north at 147th Street. There was another riding academy behind the Sons of Italy Hall on 147th Street. Charles Winslow, who owned a large estate on Hook Creek Boulevard, was an avid rider. He was commonly seen riding around Brookville Park. (Jean Kohler.)

The Rosedale Funeral Home sat at 245–01 Francis Lewis Boulevard (near South Conduit Avenue). This 1950s matchbox cover has a drawing of the funeral home's building, as well as the local exchange number LA (Laurelton) 8-1180. The home's funeral director was Rosedale Board of Trade head Kenneth W. Haslam. The Rosedale Funeral Home left the Francis Lewis Boulevard location in the 2000s. The location is now home to a Popeye's Chicken and a Dunkin' Donuts. (Author's collection.)

The Hoeffner family had a farm at the border of Rosedale and South Valley Stream, where the Queens section of Hungry Harbor Road met Ocean Avenue. Anton "Tony" Hoeffner set up a service station on the farm in 1951. The farm is long gone (it became part of the Green Acres development), but the service station still stands at Rosedale and Heatherfield Roads and is run by the third generation of Hoeffners. This advertisement is from the 1950s. (Diocese of Brooklyn.)

TIlden 4-6444 Tony Hoeffner

HOEFFNER'S SERVICE STATION
WASHING • AUTO REPAIRS • LUBRICATION
TIRES • BATTERIES • ACCESSORIES

Pick Up and Delivery Service

ROSEDALE ROAD ON HOEFFNER'S FARM

Valley Stream, N. Y.

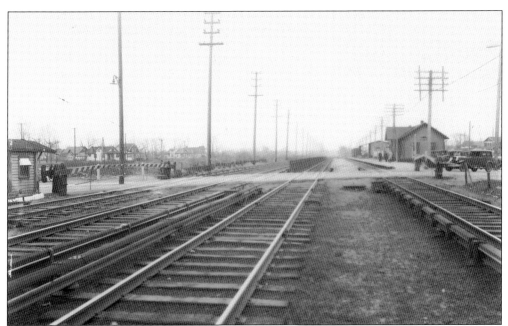

The view in this April 1934 photograph looks east across Hook Creek Boulevard toward the Rosedale railroad station. The 1889 South Side Rail Road station is on the right side, and beyond that is the original 1871 station (then being used as a storage shed). The view in the below photograph looks in the opposite direction, west, down the tracks. At right is a shack with the Rosedale name, and in the distance on the left are South Conduit Avenue and the trolley line. Careful inspection of the background reveals the Evangelical Lutheran Church of Christ, the Rosedale Diner, Spero's Service Station, and possibly the building that would become the Veterans of Foreign Wars Post 9352 (previously 766). The Rosedale Long Island Rail Road lines were elevated in 1950, and the station moved to its current location. (Both, Queens Borough Public Library, Archives, Frederick Weber Photographs.)

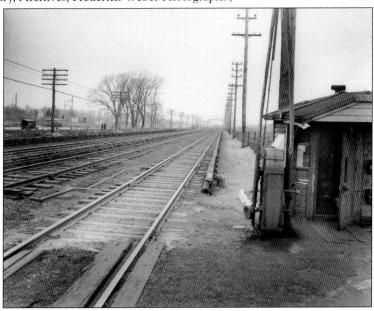

The Rosedale Vietnam War Memorial was one of the first (if not *the* first) Vietnam War memorials in the United States. It was dedicated on Memorial Day in 1968 and still stands in a triangle on South Conduit Avenue near other veterans' memorials. On the left is the 1930s VFW Post 9352 on Francis Lewis Boulevard, and where the Sunoco station stands was the home of the Rosedale Honor Roll during World War II. (Author's collection.)

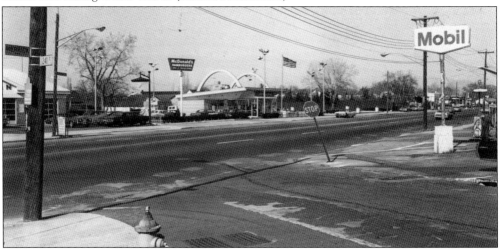

Plans for International School 240 (IS 240), on the corner of Merrick Boulevard and Brookville Boulevard, were controversial from the beginning. This May 19, 1972, photograph shows the area before construction. Construction stalled in 1974, and a rotting skeleton was left standing for years. In 1987, Thomas Theodore developed the half-built structure into Cross Island Plaza. In the background is the Cross Island Diner, which became the USA Diner in 1991. (Queens Borough Public Library, Archives, *Long Island Daily Press* Photograph Morgue Collection.)

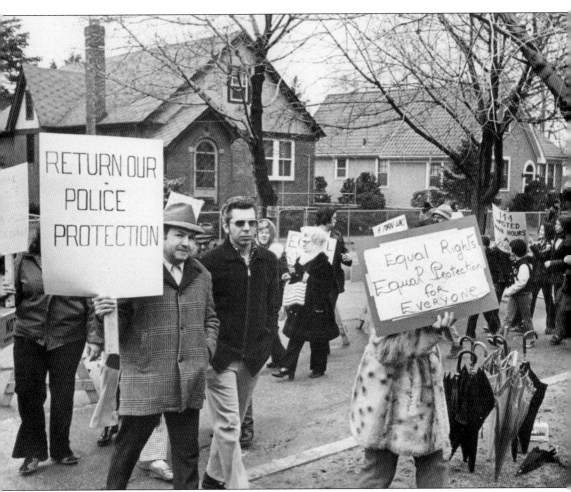

On New Year's Eve in 1974, the home of the Spencer family, immigrants from Trinidad, was pipe-bombed by two people claiming they were the Boston KKK. People of color had started moving into Rosedale in the 1970s, and a small group of bigots tried to stop this by forming ROAR (originally Return Our American Rights, later Rights Of All Rosedale) to prevent black people from buying houses. The leaders of ROAR were Michael Biggio (one of the people accused of bombing the Spencers' home), Jerry Scala, Joseph Salitz, and Joseph Ewald. ROAR participated in racist practices of refusing to sell homes to black people and protesting their neighbors who did. Eventually, a federal lawsuit over its housing tactics and a division in leadership over the Democratic district primary (George McCraken versus Leon Schneider) led to a fracturing of ROAR. ROAR's opinions were not the opinions of the majority of Rosedale residents, who were vocally opposed to this small racist group. This 1975 photograph shows ROAR protesting outside the Spencer home. (Queens Borough Public Library, Archives, *Long Island Daily Press* Photograph Morgue Collection.)

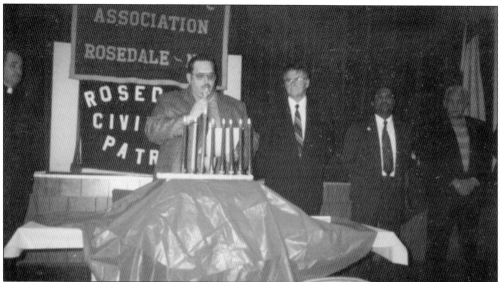

The Rosedale Civic was born out of the Rosedale Taxpayers Association in 1946. In the late 1970s, it merged with the North Rosedale Community Organization. Over time, the Rosedale Civic has had a number of prominent leaders, including William Meehan, George McCraken, James English, Fred Kress, and Irnel Stephen. Other civic groups in Rosedale included Kenneth Haslam's Rosedale Board of Trade and Joseph Albergo's Rosedale Block Association. The above photograph shows the civic association meeting at Throop Memorial Presbyterian Church for officer installation. From left to right are unidentified, Paul Mader, James English, Irnel Stephen, and unidentified. The below photograph shows the 2016 ceremony to rename a portion of 242nd Street after James English. From left to right are four unidentified, Joyce Lawrence, Ann English, Sam Elliott, Commander Lee Blackmon, Virginia Beaman, Irnel Stephen, Councilman Donovan Richards, Jerry Lemura, unidentified, Paul Mader, Madylania Chimenti, Alexander Chimenti, and unidentified. (Both, Ann English.)

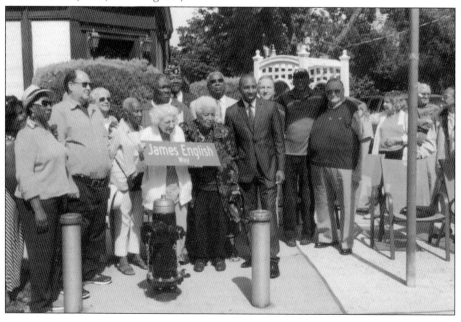

Four

OLD SPRINGFIELD, LAURELTON, AND CAMBRIA HEIGHTS

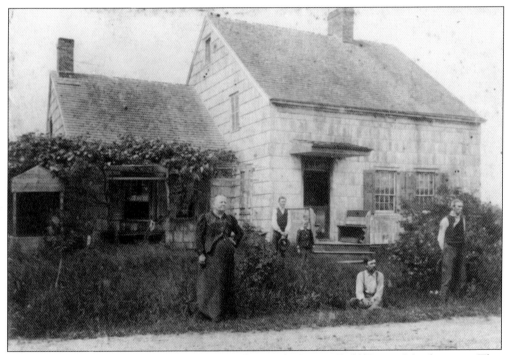

The Remsen family were some of the first settlers in the Spring Field/Fosters Meadow area. This undated photograph shows the family in front of their home near Rockaway Road and Farmers Avenue. From left to right are Sarah Jane Ludlam Remsen (1845–1907), Charles Barker Remsen (1880–1938), unidentified, Martin Remsen (1873–?), and Isaac Schenck Remsen (1849–1929). (Queens Borough Public Library, Archives, Illustrations Collection–Springfield Gardens.)

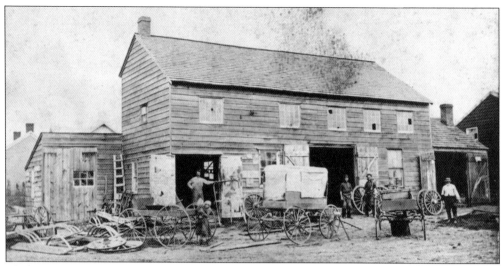

This 1885 photograph shows a store on the northeast corner of Springfield Road and Merrick Road. Most of the people in the photograph are members of the Miller family. Across the street, on the northwest corner, was L.E. Decker's General Store (established in 1854.) His store was the starting point of the America Blanchet Cup Automobile Race held on April 14, 1900. (Queens Borough Public Library, Archives, Illustrations Collection–Springfield Gardens.)

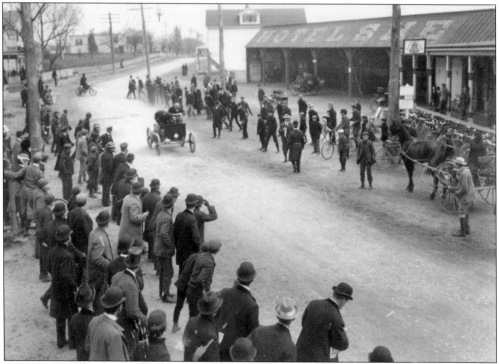

The America Blanchet Cup Automobile Race, held on April 14, 1900, was the first automobile race on Long Island (and the fourth ever in the United States). The 50-mile race, hosted by Leonce Blanchet, started at Springfield Boulevard and traveled down Merrick Boulevard to Babylon and back. The start and finish was at L.E. Decker's General Store. The race is considered a precursor to the Vanderbilt Cup Races. (Author's collection.)

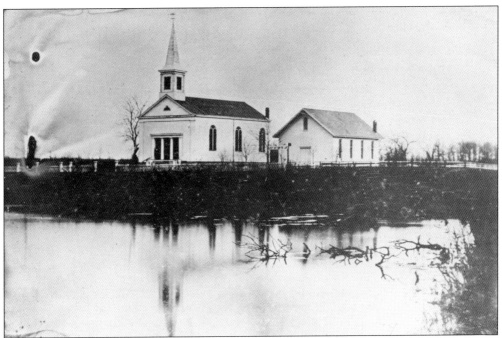

The congregation that would become the First Presbyterian Church of Springfield Gardens began meeting in 1860 in a schoolhouse. The first Springfield Presbyterian Church (above) was built in 1867 on Springfield Boulevard and 137th Avenue. Springfield Pond is in the forefront of the photograph. The second (and current) Springfield Presbyterian Church (pictured below in 1915) was built in the Gothic style in 1906. In 1927, a fire destroyed the lecture room and auditorium of the church. It still stands on Springfield Boulevard. (Above, Queens Borough Public Library, Archives, Illustrations Collection–Springfield Gardens; below, author's collection.)

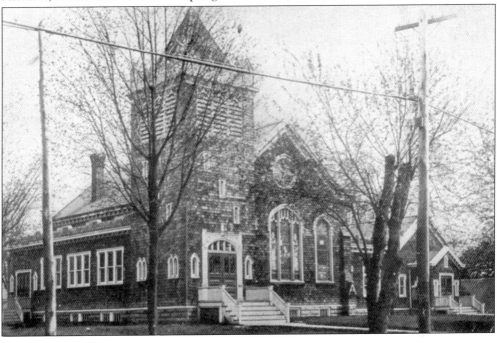

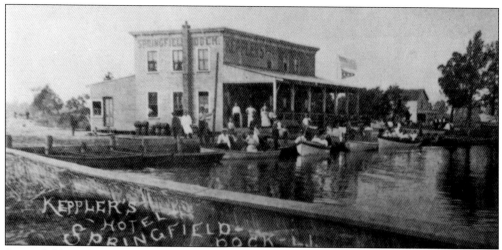

Springfield Dock was a small community near Jamaica Bay and the streams and creeks that emptied into it. The houses and hotels in the community were only accessible via boat and a nearby trolley stop on Rockaway Road. The community was eradicated during the creation of Idlewild Airport and Idlewild Park. (Queens Borough Public Library, Archives, Illustrations Collection–Springfield Gardens.)

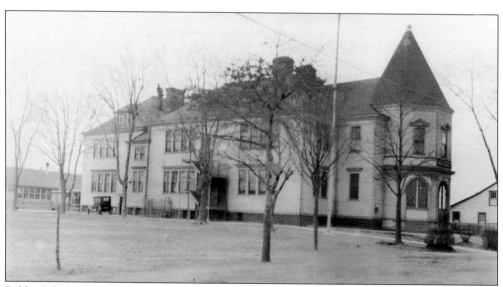

Public School No. 37, also known as the Springfield School, served the Old Springfield area from the beginning of the 20th century until it was torn down. It was located south of Springfield Pond on Springfield Boulevard, surrounded by property owned by the Higbie family. This photograph is from 1927. The current PS 37 is located in the Springfield Gardens development. (Author's collection.)

This March 14, 1910, photograph shows Springfield Road approaching the old southern division crossing of the South Side Rail Road in Old Springfield. Directly in the distance is W.P.W. Haff Coal, Wood, Hay and Feed Store; Springfield Road (now Boulevard) was home to prominent Queens families, including the Higbies, Baylises, Hendricksons, Nostrands, Mills, and Carpenters. (Queens Borough Public Library, Archives, New York State Public Service Commission Photographs.)

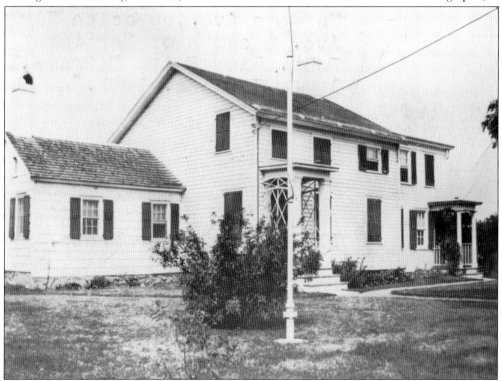

The Hendrickson family spread throughout Fosters Meadow. The John Hendrickson house stood on the west side of Farmers Avenue just south of Higbie Avenue. Other Hendricksons lived on Springfield Boulevard and in the town of Hempstead portion of Fosters Meadow. This photograph is from 1923. (Queens Borough Public Library, Archives, Eugene Armbruster Photographs.)

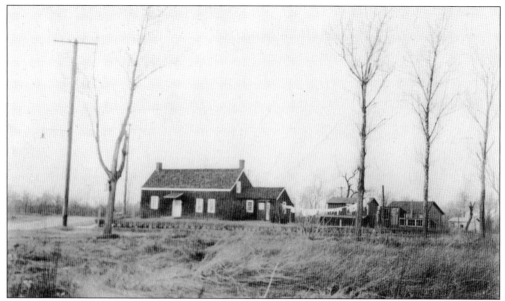

The Higbie family settled around the present-day intersection of Merrick Boulevard and Springfield Boulevard. Capt. Edward Higby obtained the land by taking part in the clearing of land for the predecessor of Merrick Boulevard. The Higbies owned land on Springfield Boulevard, and, for a time, ran a sawmill and gristmill at Cornell's Pond at 147th Avenue. The above photograph shows a Higbie family house off of Springfield Boulevard on March 9, 1927. Samuel Higbie's house was built in 1770 at the northeast corner of Springfield Boulevard and 141st Road. It has gone through many additions and changes over the years, but it is still standing. The below photograph shows the house as it appears today. Sometime after 1959, the southern half of the house was moved back away from the street, possibly for the widening of the road, and the door was moved. (Above, Queens Borough Public Library, Archives, Eugene Armbruster Photographs; below, author's collection.)

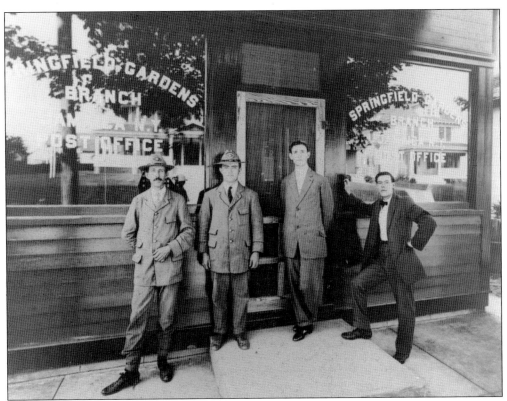

The Springfield Gardens development, created by Sherwood and Milnor, opened on the west side of Springfield Boulevard in 1906. A post office (pictured) and a train station were built in the development to accommodate residents. Higbie Avenue Station opened in 1908 at 140th and Edgewood Avenues; it closed in 1960. Higbie Avenue Station was originally named Springfield Station, but was renamed due to confusion with Old Springfield Station (which opened on Merrick Boulevard in 1873 and moved in 1885 to Springfield Boulevard until closing in 1979.) (Author's collection.)

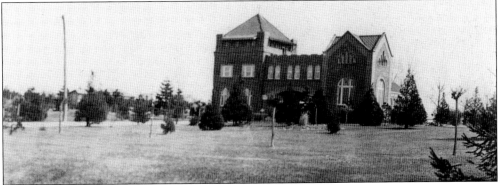

Old Springfield Cemetery, located on Springfield Boulevard, dates back to 1670. The original gravestones have deteriorated to the extent they cannot be read. Montefiore Jewish Cemetery opened on land once owned by Frances Buck and the Rottkamp family in 1908. It completely surrounds Old Springfield Cemetery but is not associated with it. Montefiore expanded to Farmingdale in 1928. This photograph of the gatehouse at Montefiore Cemetery is from March 1927. (Queens Borough Public Library, Archives, Eugene Armbruster Photographs.)

This photograph, taken between 1915 and 1920, shows the results of a snowstorm on the south side of Merrick Boulevard in Springfield Gardens between the railroad tracks and Farmers Avenue (today's Farmers Boulevard), where the original 1873 Springfield Station was approximately located at present-day 132–54 Merrick Boulevard, 70 feet west of the tracks. Sherwood Oval, the home of the Springfield Greys baseball team, was very close to the house shown in this photograph. (Queens Borough Public Library, Archives, Illustrations Collection–Springfield Gardens.)

Semiprofessional baseball team the Springfield Greys played home games at Sherwood Oval, which was at the cow pasture on the corner of Merrick and Farmers Boulevards in the Springfield Gardens Development. This ticket was for a game with the Brooklyn Bushwicks, the Greys' major rival, who played at Dexter Park in Woodhaven. The Greys began in 1928 and survived until 1948. They played other semiprofessional and Negro League teams. In 1934, they also played at Fireman's Field in Valley Stream for part of the year. (Author's collection.)

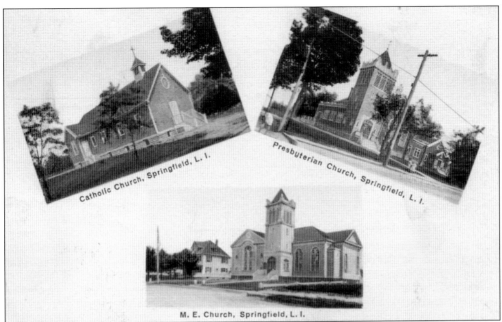

Catholic Church, Springfield, L. I.

Presbyterian Church, Springfield, L. I.

M. E. Church, Springfield, L. I.

This 1917 postcard shows three of the churches in the Old Springfield area. On the bottom is the First Methodist Episcopal Church of Springfield, located on Farmers and Dennis Avenues. It was established in 1867 and still stands today. The parsonage is to the left of the church in this image. (Author's collection.)

William Reynolds, the state senator who built Long Beach and Dreamland in Coney Island, tried to develop the Laurelton area in 1906. This advertisement calls the garden suburb one-family houses "highly restricted," which means racist deed restrictions. Reynolds's development failed and he moved on, but in the 1920s and 1930s, Laurelton was developed and became home to a large Jewish, Irish, Italian, and German population. (Queens Borough Public Library, Archives, Illustrations Collection–Laurelton.)

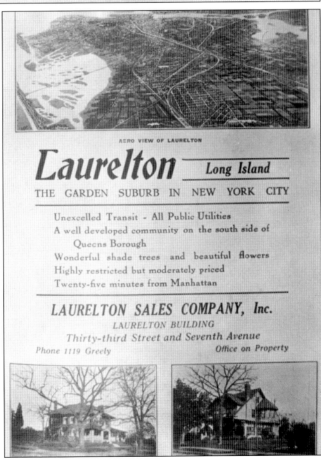

AERO VIEW OF LAURELTON

Laurelton — Long Island

THE GARDEN SUBURB IN NEW YORK CITY

Unexcelled Transit - All Public Utilities
A well developed community on the south side of Queens Borough
Wonderful shade trees and beautiful flowers
Highly restricted but moderately priced
Twenty-five minutes from Manhattan

LAURELTON SALES COMPANY, Inc.

LAURELTON BUILDING
Thirty-third Street and Seventh Avenue
Phone 1119 Greely Office on Property

In 1911, the West Side Tennis Club of Manhattan was looking for a bigger area to which to move the club. Laurelton was one of the sites under consideration. Ultimately, a new stadium was built in Forest Hills that still stands. In the background at far right are some of New York State senator William Reynolds's original houses for his development mentioned on page 99. (Queens Borough Public Library, Archives, Illustrations Collection–Laurelton.)

Doc Mack's Lunch Stop Diner was located on Merrick Boulevard and 233rd Street, near the Schmitt property, in Laurelton. Not much information is known about the diner when it was there, but it later moved into Valley Stream under a different name. (Valley Stream Historical Society.)

Capt. Ernest F. Engerer arrived in Laurelton in the 1920s (he came from Germany in 1914 and jumped off a ship in Boston). He earned the "captain" title in the German army during World War I. Captain Engerer set up a police dog training academy and wild animal circus on Merrick Road west of the Schmitt farm. Engerer was an eccentric character who claimed to have lost his left arm to a lion attack in 1918. In 1964, during one of his road shows in Winston-Salem, North Carolina, he was killed by a lion named Monte while the horrified audience watched. Below is a business card for George W. Bray, the contracting agent and banner solicitor for Captain Engerer's Wild Animal Circus. (Both, author's collection.)

George W. Bray

Contracting Agent and Banner Solicitor
Capt. Engerer's Wild Animal Circus

P. O. BOX 12 ROSEDALE, L. I., N. Y.

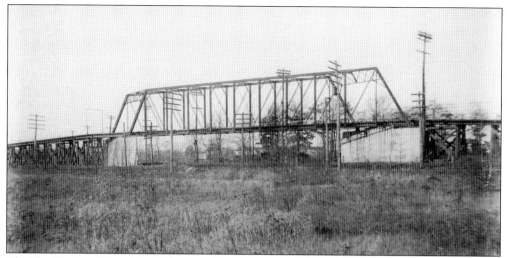

The New York and Long Island Traction Company ran a trolley line along the south shore of Long Island, all the way to Freeport in 1925. This photograph shows the trolley running on a bridge over the Long Island Rail Road's Montauk and Atlantic rail line tracks in Laurelton. (Queens Borough Public Library, Archives, Illustrations Collection–Laurelton.)

Bernard Rottkamp was born on November 17, 1822, in Westphalia, Prussia. He immigrated to New York in 1847 and married Caroline Engel. In 1861, he moved his farm from Newtown to Cambria Heights. His old farmhouse still stands at 225–08 Linden Boulevard, on the south side. Linden Boulevard was called Central Avenue and Lazy Lane in its early days and Foch Boulevard in the 1920s. The Froehlich farm was across the street. (Author's collection.)

Cambria Heights was entirely a farming community until 1923, when 163 acres were developed by Oliver B. LaFreniere and financed by the Cambria Title Savings and Trust Company (a bank based in Cambria County, Pennsylvania). This November 11, 1948, photograph shows the intersection of Springfield and Linden Boulevards. Part of the empty lot shown on Linden Boulevard is now Farmbia Food Center. (Queens Borough Public Library Archives, Illustrations Collection–Cambria Heights.)

Cambria Heights got its name from the Cambria Title Savings and Trust Company, which financed the development from farms to the houses shown in this 1948 photograph. The "Heights" came from the high elevation of the area. Jewish, German, Irish, and Italian residents first populated Cambria Heights, but after World War II, the area became primarily black. It is now an upper-middle-class Caribbean neighborhood. (Queens Borough Public Library Archives, Illustrations Collection–Cambria Heights.)

In March 1966, a street-grading project started in the Brookville section of Springfield Gardens/ Rosedale. The construction tore up 222nd and 223rd Streets between 145th and 147th Avenues. The project was scheduled for completion in June, but, as shown in this August 5, 1966, photograph, it lasted much longer. Residents had to deal with grading issues and ski slope–like driveways for months until the city finished the job. Damage to houses and cars totaled in the thousands. (Queens Borough Public Library, Archives, *Long Island Daily Press* Photographs Morgue Collection.)

This 1920s aerial image of Cornell Pond, with a view looking south, shows a newly developed Springfield Gardens. This area of Springfield Gardens, east of Cornell Pond and west of Brookville Park, is also known as Brookville. At the very top of this image is Idlewild Park. (Ann English.)

Five

Valley Stream, Franklin Square, and Floral Park

Life Insurance Loans

Loans at 3% per annum on
the Cash Surrender Value of Policies.

Present Loans May be Refinanced.

Valley Stream National Bank & Trust Company
on Rockaway Avenue in Valley Stream, N. Y. Phone Valley Stream 7500

Member Federal Deposit Insurance Corporation Member Federal Reserve System

Valley Stream National Bank was started on Rockaway Avenue in Valley Stream in 1927 and soon expanded to other neighborhoods as Valley National Bank. A branch opened in the parking lot of the King Kullen shopping center in Hewett. Another opened on Central Avenue near Lieber Funeral Home, and yet another in Elmont on Dutch Broadway next to Jim Dandy Cleaners. Valley National Bank was taken over by Chase. (Author's collection.)

The western and northern parts of Valley Stream were influenced by the development of Fosters Meadow. On some early 20th-century maps, the western section is labeled as Fosters Meadow. This March 29, 1938, photograph shows Central Avenue in Valley Stream in a view looking south from the train crossing toward Mill Road. To the right of the sign for Chanin's new Green Acres development are the Green Acres homes and the former residences of the Reisert, Watts, and Corcoran families. (Queens Borough Public Library, Archives, Frederick Weber Photographs.)

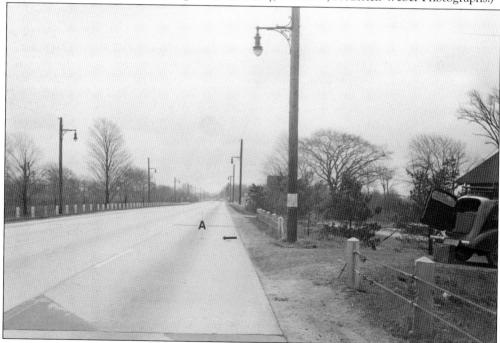

Terrace Place in Valley Stream cut through the railroad lines and continued south through farms to better access the Hungry Harbor area. Starting in May 1906, the train made stops at Terrace Place (at the Clear Stream Road Stop) for employees of the Royal Land Company. In 1932, it was still a private stop. Service ended before a photographer took this 1943 picture showing Sunrise Highway at Terrace Place. (Nassau County Police Museum.)

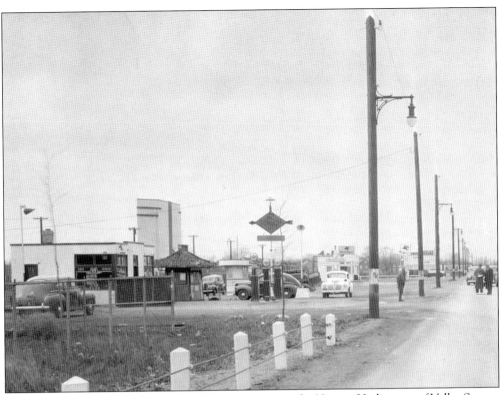

The 169-acre properties of Frederick and George Reisert in the Hungry Harbor area of Valley Stream became Rogers Airport in 1928 and Curtiss Field the following year. The Chanin Organization started to develop the old Reisert farm as the Green Acres neighborhood in the 1930s. These two photographs—above from 1941, and below from 1939—show the far end of Green Acres (the former Cornell, Watts, and Atwater properties) at the Rosedale border. The Sunrise Drive-In Theatre, the first open-air movie theater in New York State, opened in August 1938. It could hold 500 cars. Its towering screen is visible on the far left in these photographs. The Sunrise Drive-In was demolished in 1979. Just south of Sunrise Drive-In were the Winslow and Cusamano estates. (Both, Nassau County Police Museum.)

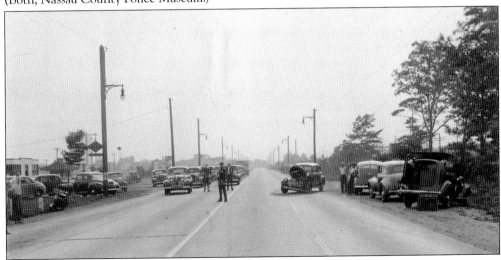

Henry Hendrickson, mayor of Valley Stream and a member of the large Hendrickson family, grew up on the corner of Henry Street and Hendrickson Avenue in the house shown on the right. The streets were named after Hendrickson's grandfather, also named Henry Hendrickson. The Fletcher family owned the property south of Hendrickson Avenue. In the distance are the farms of the March family and the Stick family. Johan Marz came to Fosters Meadow in 1860 and changed his name to John March. He purchased the farm on Central Avenue just north of Hendrickson Avenue. In 1877, his son Michael took over the property and married Amelia Reisert that same year. Michael March later purchased another farm on Dutch Broadway in Elmont near where the Gouz Dairy was. Michael's sons took over the farm after their father could no longer run it; Joseph March ran the Central Avenue farm, while Fred March ran the Dutch Broadway farm. The farm was reduced in size in 1934 during the construction of the Southern State Parkway, and the Marches soon sold to developers. (Nassau County Police Museum.)

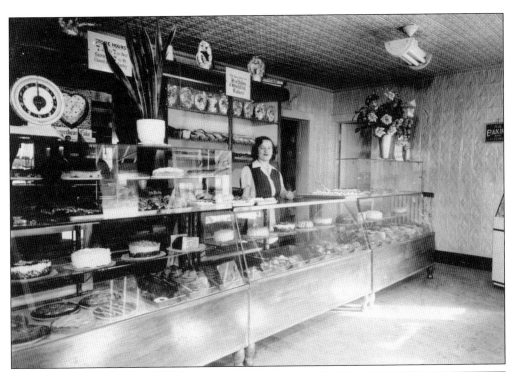

Fortunata Regina Ceccacci Calabrese (pictured above) and John Joseph Calabrese opened Everbest Bakery in 1947 at 347 Central Avenue, just within the borders of the village of Valley Stream. They retired in 1960, and their son Joseph (pictured at right) took over the business. He sold the bakery to his son John Calabrese in 2000, and John sold it in 2004. In the above photograph, Fortunata, a first-generation American, stands behind the counter shortly after the store opened in 1947. At right, Joseph, age 39, works the machinery in May 1969. (Both, John and Charlene Calabrese.)

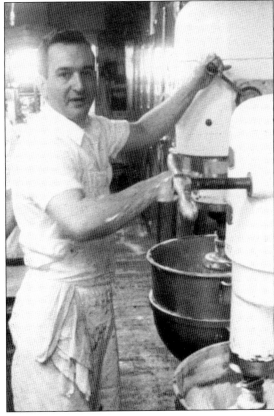

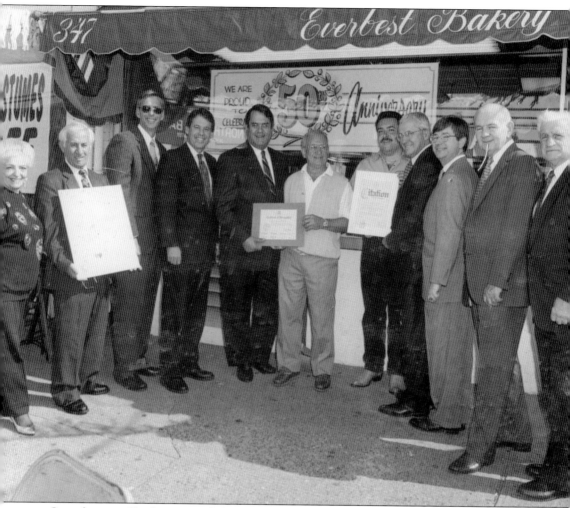

Over the years, Everbest expanded into Cully's Ice Cream Shop, which was located next door on Central Avenue. It was renamed Everbest Ice Cream Shop. Everbest owner John Calabrese's wife, Charlene, ran Charlene's Stationery in the same group of stores. In the 2000s, Everbest closed in Valley Stream and moved to East Northport, where it is still located. This photograph is from Everbest's 50th anniversary in 1997. Pictured are, from left to right, civic leader Fay Harrison, Valley Stream Village special building inspector Michael Stufano, Valley Stream Village trustee Richard Coffman, Nassau County legislator Francis X. Becker Jr., town of Hempstead senior councilman Anthony Santino, Everbest owners Joseph Calabrese and John Calabrese, Valley Stream mayor James Darcy, Valley Stream Village justice Robert G. Bogle, Valley Stream Village trustee Edward Cahill, and Valley Stream Village trustee Guido Cerenza. (John and Charlene Calabrese.)

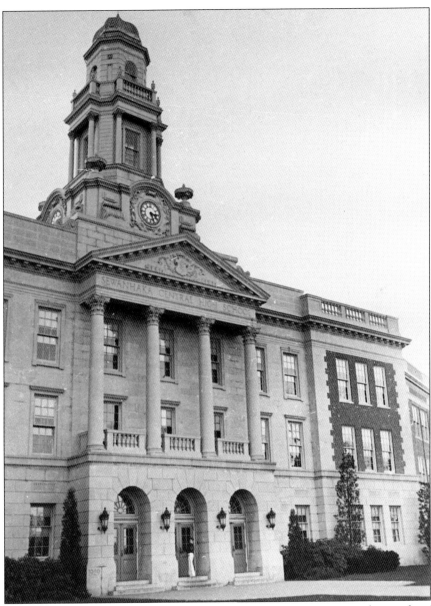

Sewanhaka High School (pictured) was constructed in Floral Park in 1929 and opened in 1930 to serve as a high school for the Elmont, Floral Park, Bellerose, Stewart Manor, and Franklin Square areas. Previously, if a student wanted to go to high school, he or she had to go to Hempstead or Jamaica. The overcrowding of those schools led to the Village of Floral Park creating a Central High School District in 1926. The school expanded in 1936 to handle more students, but it was clear that more high schools were needed. In 1956, H. Frank Carey High School opened to serve students in Franklin Square, West Hempstead, Garden City South, and parts of Elmont. That same year, New Hyde Park Memorial opened for students in the north part of the district, and Elmont Memorial opened for the boom in population on the former farmland. Finally, in 1957, Floral Park Memorial opened to serve Floral Park, Bellerose, and South Floral Park. Alva T. Stanforth Junior High School served the district from the 1950s to the 1980s but was closed after the 1983 school year. (Nassau County Photograph Archive.)

Floral Park–Bellerose Elementary School opened in 1929 right behind Belmont Park to accommodate students in the western part of Floral Park, Bellerose, and Bellerose Terrace. The Floral Park–Bellerose School District only has one other school—John Lewis Childs Elementary School, named after the founder of the village. (Nassau County Photograph Archive.)

Valley Stream Central High School District had its origins in 1923, when Brooklyn Avenue Elementary School temporarily housed students at the high school level. In 1925, the District 13 school on Wheeler Avenue became the official Central High School. That lasted until 1929, when Valley Stream Central High School was built on Fletcher Avenue. Two more high schools and a junior high school later became part of the district. (Nassau County Photograph Archive.)

The Rosedale Gardens area of Valley Stream was built on property owned by Harriet Winslow. The small neighborhood had its own Broadway and alphabetical streets from Ash to Gold. The Krapf family owned farmland in Rosedale Gardens (also called Winslow Estates) in the 1920s. The photograph at right shows the empty land on Cedar and Dean Streets. The below photograph shows Jean Kohler (then Krapf) climbing over a fence in the Rosedale Gardens area. Most land in the area contained either empty lots or farms. (Both, Jean Kohler.)

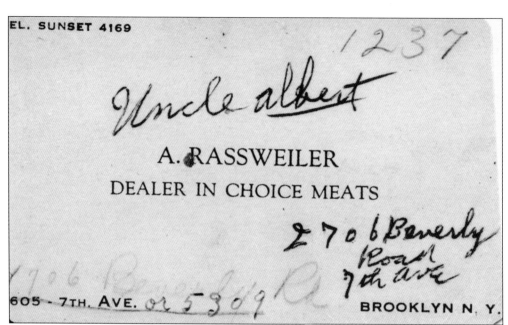

The Rassweiler family owned land near Casper Gunter and the Boenings on the north side of Merrick Road, east of Central Avenue in Valley Stream. Albert Rassweiler was known for his Brooklyn butcher shop. (Jean Kohler.)

The Reising family had homes throughout Fosters Meadow, but their main farm was north of the Woodmere Woods on Hungry Harbor Road, near Remson Hendrickson and Anton Hoeffner. Their original farmhouse still stands and has been condemned by the town. Across the street still stand two later farmhouses and a barn. Part of the Reising property was bought by the Auckley family, who opened a service station on the corner. (Author's collection.)

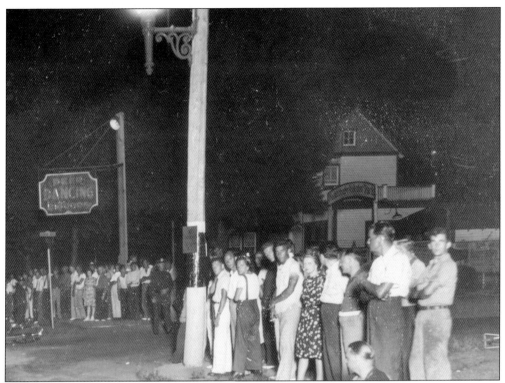

The Plattdeutsche Altenheim was built in 1922 on Hempstead Turnpike in Franklin Square as an old folks home for German Americans. Running along its east side is Renken Boulevard, named for Martin Renken, president of the Plattdeutsche Altenheim-Gesellschaft. The Plattdeutsche Park Restaurant, located next door to the Altenheim, has been around since 1916. Both buildings still stand, and the restaurant is known for its Oktoberfest and Oom-Pah-Pah music nights. In the 1939 photograph above, the Plattduetsche Park Restaurant is visible behind the crowds on Renken Boulevard. In the below photograph of the Herman Boulevard gas station, the restaurant and Plattduetsche Altenheim are visible in the background. (Both, Nassau County Police Museum.)

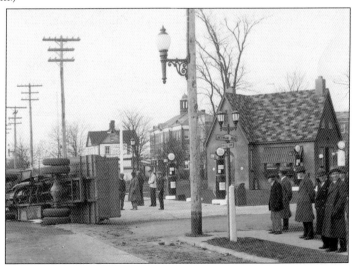

Court House Road forks off of New Hyde Park Road in this 1944 photograph of Franklin Square. At the fork was a Mobilgas Station, as well as the Franklin Square Honor Roll and the Veterans' Monument. The Veterans' Monument was built in that triangle in 1938 and remained there until 1960, when it was moved to Rath Park. (Nassau County Police Museum.)

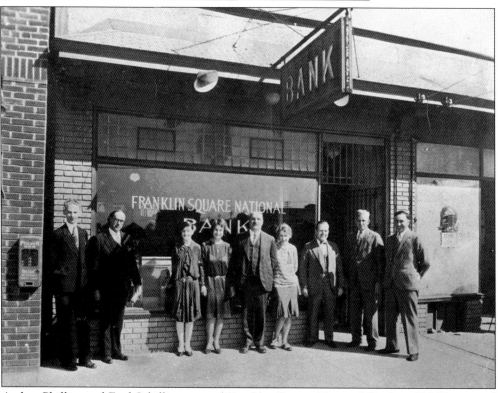

Arthur Phillips and Fred Schilling opened Franklin Square National Bank at 334 Hempstead Turnpike in 1926. It grew to become one of the largest banks in the country and was the first to offer a bank credit card. The bank's 1929 landmark building on the corner of Hempstead Turnpike and James Street is listed in the National Register of Historic Places. (Nassau County Photograph Archive.)

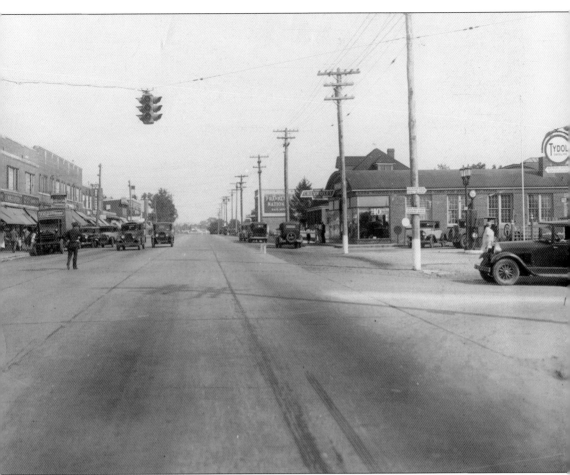

George Hoffman Chevrolet and August Hoffman's Super Service Station stood on the southeast corner of Franklin Avenue and Hempstead Turnpike in Franklin Square. Behind them was Jacob Hoffman's 87-acre farm, and directly east of the Chevrolet dealership is the Hoffman homestead (the roof is visible at right in this image). The Hoffman Chevrolet showroom, with its distinctive curved roof, still exists but has been renovated and expanded over the years to form a strip of stores. The back, still visible as part of Astoria Bank, is most noticeable in the rear parking lot. Until 1929, this corner was home to the Hoffman Hotel, which was destroyed by fire. George Hoffman opened the Chevrolet dealership as a garage in 1916 and ran it until the 1950s. He also had a used-car lot located diagonally across the street. In the background is the Franklin Square National Bank, and across Hempstead Turnpike is the former location of the Kalb Hotel, which was originally owned by August Kalb and later by Jacob Hoffman. Beyond that, on New Hyde Park Road, was Andrew Hoffman's 1923 house, which is now the Franklin Funeral Home. (Nassau County Police Museum.)

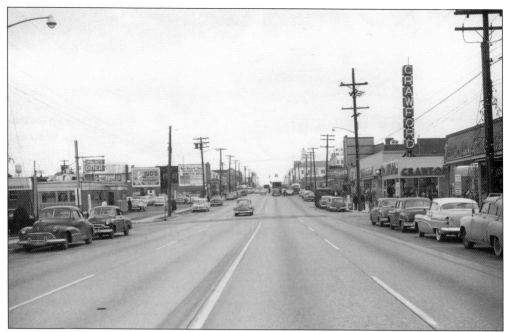

The Franklin Square movie theater opened on the former Kinsey estate in 1931. It is visible on the right side beyond the Crawford sign. In the 1956 photograph above, the theater still has its original round marquee. Beyond the movie theater is the cupola of Franklin National Bank, and across the street is Ramona-Lee Pastry Shop. In the below photograph, with a view looking west from Franklin Avenue in 1972, the theater (on the left) has a new square marquee. On the north side of the road, next to Ramona-Lee Pastry Shop is the Franklin Square Wetson's. The north side of Hempstead Turnpike was once the Peter J. Herman 20-acre farm. Herman's 1902 house still stands at 19 Herman Boulevard. (Both, Nassau County Police Museum.)

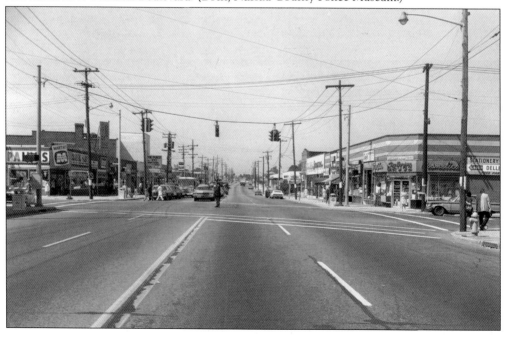

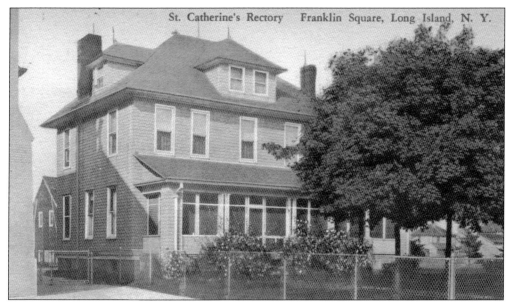

The early Roman Catholic residents (who were mostly German) of Franklin Square had to travel all the way to St. Boniface in Elmont to attend church services. In 1908, after petitioning the Diocese of Brooklyn, the bishop granted Franklin Square its own Roman Catholic church—St. Catherine of Sienna. The church was built just north of Hempstead Turnpike on New Hyde Park Road. Its rectory (pictured) was built in 1914. The church went through renovations in 1925 and still stands today. (Author's collection.)

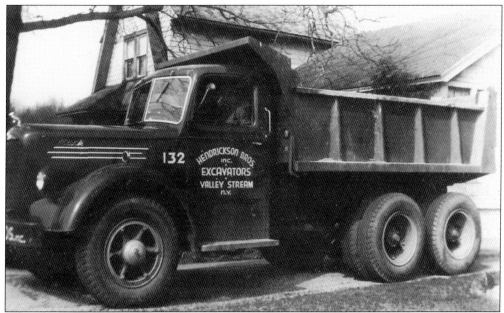

Valley Stream Republican leader John Corner Hendrickson, of the Fosters Meadow Hendrickson family, started what became Hendrickson Brothers, Inc., in Valley Stream in 1903 and retired in 1918. His three sons—Valley Stream mayor Arthur J. Hendrickson, G. Freeman Hendrickson, and Frank C. Hendrickson—took over the business and incorporated in 1922. Milton Hendrickson ran the company until it dissolved in the mid-1990s. (Author's collection.)

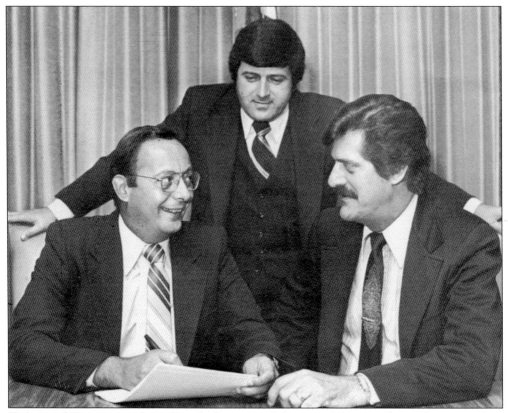

Hempstead Town councilman Joseph Cairo stands between Hempstead presiding supervisor Alfonse D'Amato (left) and president of Gateway-to-Nassau Richard McCabe in this 1970s image. Cairo was on Hempstead's town council into the 1990s and still plays a major role in the Nassau Republican Party as the executive leader of North Valley Stream. In 1981, D'Amato, of Island Park, replaced Jacob Javits in the US Senate; he served until 1999. (Elmont Memorial Library.)

Hempstead Town councilman Joseph Muscarella (left) from Elmont poses for a photograph with Hempstead Town councilman Easa Easa from West Hempstead. Easa was the son of Palestinian immigrant Easa Jaghab, whose name was reversed when he came to the United States. Easa sat on the Hempstead Council from 1960 to 1969 and spent 18 years running Nassau OTB. He was also the Republican executive leader of West Hempstead. He died on November 8, 2016. (Vincent Muscarella.)

Henry Hendrickson was born in 1903 in Fosters Meadow at the corner of Henry Street and Hendrickson Avenue. In 1930, he was elected constable of the town of Hempstead. In 1935, he was elected Nassau County sheriff. In 1938, he was appointed marshal in the Second District Court. Finally, in 1941, he was elected mayor of the village of Valley Stream; he was reelected twice. Arthur J. Hendrickson, a second cousin once removed, was also mayor (1929–1932) as well as Valley Stream Republican leader (1921–late 1960s). (Peter Bauer.)

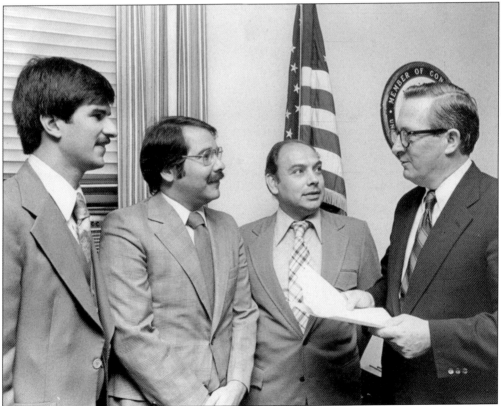

A very young Vincent Muscarella met Congressman John W. Wydler in his office. Muscarella is the son of town councilman Joseph Muscarella and later became a state assemblyman, county legislator, and Republican executive leader from Franklin Square East. His brother Joseph is a town of Oyster Bay councilman. Pictured here are, from left to right, Vincent Muscarella, unidentified, Giuseppe Battista, and Congressman Wydler. (Vincent Muscarella.)

CROSS ISLAND FRUITS

Wholesale — Retail

FEATURING ALL NEW DELICATESSEN &

CATERING DEPARTMENT

— Full Line of Quality Cold Cuts at Lowest Prices —

1285 HEMPSTEAD TURNPIKE ELMONT, N. Y.

Cross Island Fruits has been in North Lynbrook for so long that no one questions its name. Lynbrook is nowhere near the Cross Island Parkway, but Elmont is. Cross Island Fruits was located at 1285 Hempstead Turnpike before moving to Hempstead Avenue in Lynbrook. The above advertisement is from the 1950s. The below image is a 1937 photograph of where Cross Island Fruits would soon be located—at 1285 Hempstead Turnpike at the southeast corner of Hunnewell Avenue near the border of Franklin Square, where the Chrysler billboard is located at right. In the background is the top of the Plattdeutsche Altenheim. The old Cross Island Fruits building is still standing. (Above, Nick Famiglietti; below, Nassau County Police Museum.)

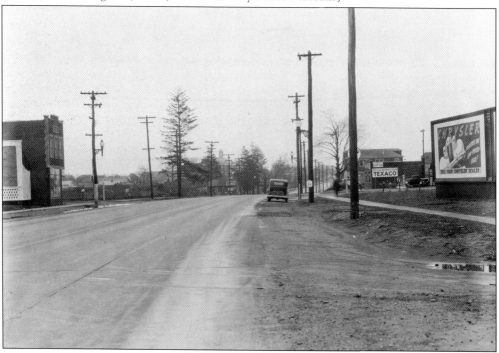

In Valley Stream, 49 North Central Avenue was the location of the home and store of Oscar Jacob Pflug (third from left). The structure seen in this 1915 photograph was built in 1894. After the Pflug family left, the structure became apartments. In February 2014, a fire ripped through the store and house, damaging it beyond repair; it was demolished in 2015. Pflug's grandfather, Leopold, came to America from Germany in the late 19th century. His son Jacob moved to Fosters Meadow, where Oscar was born on April 26, 1874. (Nassau County Photograph Archive.)

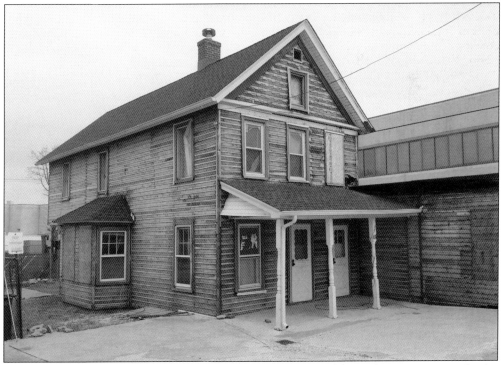

Oscar Pflug was also involved in politics. In 1896, he was a Republican election inspector for the town of Hempstead. In 1925, he was elected as a one-year trustee for the village of Valley Stream during the village's first election as an incorporated entity. Pflug died on February 25, 1934. His family remained in the house for another 30 years. (Author's collection.)

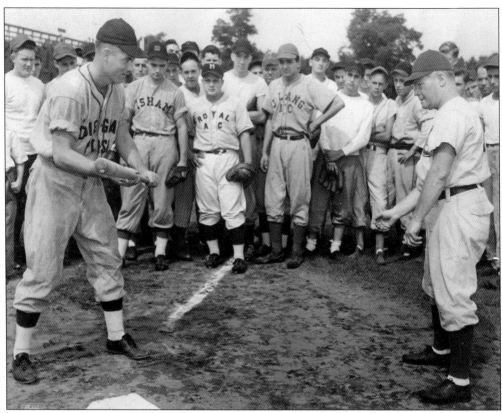

On August 21, 1946, the Chicago Cubs sent scout Tom Taguer to Fireman's Field in Valley Stream to have open tryouts for its farm teams. The event attracted over 100 prospects from all over Long Island and New York City. Above, Taguer is teaching 23-year-old Wylie Hunt how to bunt as other prospects watch. Below, 17-year-old Paul Henze slides into third while third baseman Louis Tottora and Taguer watch. (Both, Nassau County Photograph Archive, photograph by Milton Platnick.)

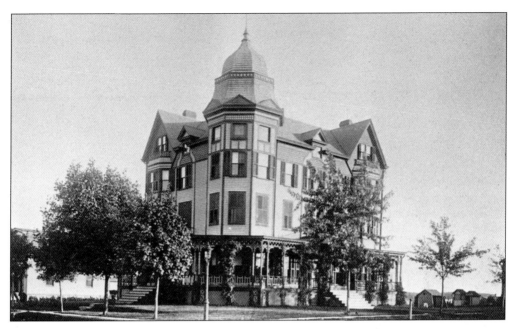

Floral Park was originally known as East Hinsdale and Plainfield until seed businessman John Lewis Childs developed the main downtown area and renamed it. Floral Park incorporated in 1908, and Childs was elected its first president (the title was later changed to mayor). Above, in 1895, the Floral Park Hotel greeted visitors at the corner of Tulip and Violet Avenues. When Childs developed the area, he named most of the new roads after flowers and trees and renamed roads that were already in place. Tulip Avenue was originally called Light Horse Road and was the main thoroughfare, along with Plainfield Road, to get to Little Neck Parkway and New Hyde Park from Fosters Meadow. Below, Floral Parkway runs from the village's center to the border of South Floral Park and is one of the most beautiful roads in Nassau County. (Above, Nassau County Photograph Archive; below, author's collection.)

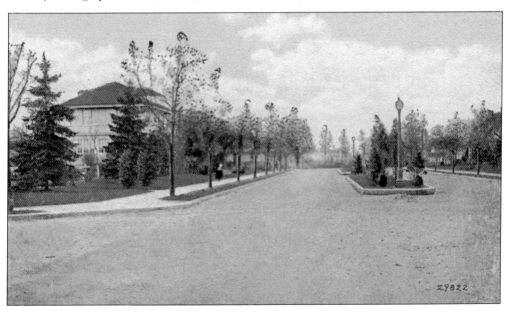

Ambrose "Andy" Schmitt continued the Schmitt farming tradition in Fosters Meadow by setting up shop on the west side of Hook Creek Boulevard in Rosedale, just north of Merrick Road. Over the years, he sold off parts of the property for development, leaving very little for farming. Eventually, he completely shut down the farming business. Schmitt died in 2016 at the age of 91. (Author's collection.)

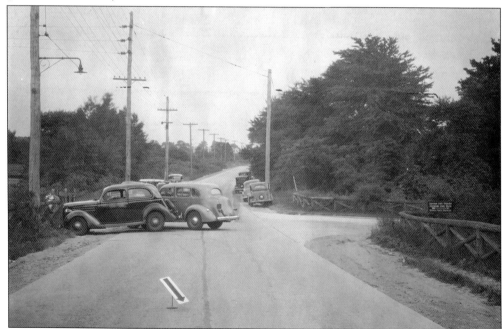

This 1938 photograph shows a car accident at North Corona Avenue and the Southern State Parkway entrance in North Valley Stream. The land on the far right later became the site of Franklin Hospital, which is now named Long Island Jewish Valley Stream. The roadway leading to the Southern State Parkway was renamed Blakeman Drive after Valley Stream village attorney and assemblyman Robert Blakeman, who served as the first president of Franklin Hospital. (Nassau County Police Museum.)

Elmont, Floral Park, Franklin Square, and South Floral Park were almost completely developed by 1951. In this aerial photograph, the Rottkamp farm is visible just south of South Floral Park at the center of the picture. The old Belmont racetrack is visible on the left; the main tracks are cut off, but the practice track is fully visible. Also, the no longer extant straight course runs through all the courses. Some farmland in Franklin Square also remains on New Hyde Park Road at Tulip Avenue on the far right. Other landmarks visible in this image include Beth David Cemetery and Wal-Cliffe (at the bottom) and Sewanhaka High School and Covert Avenue School (just right of the center). (Elmont Memorial Library.)

DISCOVER THOUSANDS OF LOCAL HISTORY BOOKS FEATURING MILLIONS OF VINTAGE IMAGES

Arcadia Publishing, the leading local history publisher in the United States, is committed to making history accessible and meaningful through publishing books that celebrate and preserve the heritage of America's people and places.

Find more books like this at
www.arcadiapublishing.com

Search for your hometown history, your old stomping grounds, and even your favorite sports team.

Consistent with our mission to preserve history on a local level, this book was printed in South Carolina on American-made paper and manufactured entirely in the United States. Products carrying the accredited Forest Stewardship Council (FSC) label are printed on 100 percent FSC-certified paper.

MADE IN THE